# Design and Technology

## Textiles Technology

**KS3**

Julie Boyd
Geraldine George
Paul Anderson
Debbie Eason

Text © Julie Boyd, Geraldine George, Paul Anderson and Debbie Eason 2011

The right of Julie Boyd, Geraldine George, Paul Anderson and Debbie Eason to be identified as authors of this work has been asserted by them in accordance with the Copyright, Designs and Patents Act 1988.

All rights reserved. No part of this publication may be reproduced or transmitted in any form or by any means, electronic or mechanical, including photocopy, recording or any information storage and retrieval system, without permission in writing from the publisher or under licence from the Copyright Licensing Agency Limited, of Saffron House, 6–10 Kirby Street, London, EC1N 8TS.

Any person who commits any unauthorised act in relation to this publication may be liable to criminal prosecution and civil claims for damages.

Published in 2011 by:
Nelson Thornes Ltd
Delta Place
27 Bath Road
CHELTENHAM
GL53 7TH
United Kingdom

11 12 13 14 15 / 10 9 8 7 6 5 4 3 2 1

A catalogue record for this book is available from the British Library

ISBN 978 1 4085 0813 8

Cover photograph: Lee Strickland/Getty Images
Page make-up by Pantek Arts Ltd, Maidstone
Printed and bound in Poland by Drukarnia Dimograf

## Acknowledgements

**Actifwear Ltd**: p57; **Alamy**: p16 (ELC), p19 (Jack Sullivan), p20T (allesalltag), p44BL (Hypermania), p60B (CorbisRF), p77TR Markos Dolopikos; **Alessi**: p23; **Art Archive**: p80; **Cheryl Kolander, Aurora silk, Portland**: p39BL; **British Standards Institution**: p20M, p20M, p48T, p48B; **British Toy and Hobby Association**: p48M; **Fotolia**: pvi – all, p3B, p9, p12B, p18L,p30, p32, p33B, p40, p43T, p53B, p61UM, p66R, p70TR, p70BR, p72, p73TL, p73TM, p73BM, p75; **Getty**: p26T, p34 (Photographer's Choice), p46T (Digital Vision), p74B (AFP), p81T (Hulton Archive), p81M (Keystone); **Global textiles**: p16M; **Harlequin Fabrics & Wallcoverings**: p67; **Heidi Ambrose-Brown**: p26B, **iStockphoto**: pv, p3T, p14 – all, p16L, p16R, p18R, p21, p25T, p25B, p33T, p37– all, p38, p39T, p39BR, p42 – all, p43B, p44BR, p45, p46M, p46B, p47, p54, p55, p64, p65 – all, p66L, p71, p73BL, p73BR, p74T; **Lyocell**: p13; **Paul Boyd**: p50L, p50R, p51, p58L, p58R, p59M, p59R, p60T, p61T, p61LM, p61B, p62, p63T, p63M, p63B, p68L, p68R, p69T, p69B, p70TL, p70BL; **Photolibrary**: p81B (Roberto Herrett); **Primark**: p79; **Public domain**: p12T, p52; **RexFeatures**: p77 M (Vittorio Zunino Celotto), p77B (Richard Young ), p78 David Levenson, p79T; **Speedo International Ltd**: p53T.

Thank you to all the students of Driffield School for their examples of Textiles Technology used in this book.

# Contents

Introduction to Textiles Technology — v

## Chapter 1 Deciding what needs to be made
1.1 Reasons for product development — 2
1.2 Understanding the design brief — 4
1.3 Research — 6
1.4 Product analysis — 8
1.5 Specification — 10

## Chapter 2 Sustainability
2.1 Environmental concerns — 12
2.2 The six Rs — 14
2.3 The six Rs continued — 16

## Chapter 3 Design influences
3.1 Social and cultural issues — 18
3.2 Laws and standards — 20

## Chapter 4 Presenting design ideas
4.1 Presenting and developing ideas — 22
4.2 Sketching and rendering — 24
4.3 CAD — 26

## Chapter 5 Preparing for making
5.1 Modelling and pattern drafting — 28
5.2 Production planning — 30
5.3 CAM and CIM — 32

## Contents

### Chapter 6 Evaluation
| | | |
|---|---|---|
| 6.1 | Evaluation | 34 |

### Chapter 7 Materials and components
| | | |
|---|---|---|
| 7.1 | Fibres and fabrics | 36 |
| 7.2 | Fibres and fabrics continued | 38 |
| 7.3 | Fabric construction | 40 |
| 7.4 | Fabric construction continued | 42 |
| 7.5 | Finishing fabrics | 44 |
| 7.6 | Fabric choice and characteristics | 46 |
| 7.7 | Labelling | 48 |
| 7.8 | Textiles components | 50 |
| 7.9 | Smart and modern materials | 52 |

### Chapter 8 Making
| | | |
|---|---|---|
| 8.1 | Textiles equipment | 54 |
| 8.2 | Using a sewing machine | 56 |
| 8.3 | Seams and seam finishes | 58 |
| 8.4 | Shaping techniques and pockets | 60 |
| 8.5 | Finishing and fastenings | 62 |
| 8.6 | Colouring fabric | 64 |
| 8.7 | Fabric printing | 66 |
| 8.8 | Appliqué | 68 |
| 8.9 | Quilting and patchwork | 70 |
| 8.10 | Embellishment | 72 |
| 8.11 | Manufacturing in industry | 74 |

### Chapter 9 Case studies
| | | |
|---|---|---|
| 9.1 | Famous designers | 76 |
| 9.2 | Designing for others | 78 |
| 9.3 | Product development | 80 |

| | |
|---|---|
| Glossary | 82 |
| Index | 86 |

# Introduction to Textiles Technology

## Textiles Technology

Our world is full of products that are designed and made from textiles materials. From the moment you wake in the morning, your whole day will be affected by textiles. From the bed that you climb out of, to the towel you use, the clothes and shoes you wear, the sofa you sit on, the car that brought you to school, the bag you carry ... every one of these products and many, many more are designed and made using textiles materials.

## The structure of this book

This book is divided into two sections. The first section takes you through the process of designing a product. This will help you to build up the skills that you need to design successful products. The second section will help you to improve your knowledge of materials and making activities. This will support you to successfully make products.

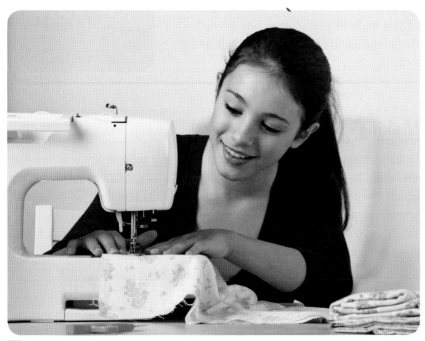

A  Student at a sewing machine

## Designing

You need to understand the different design needs that a product must meet. This will help you to generate ideas for effective products. You will learn techniques that will help you become a creative designers and these will help you to present your ideas to others. You will also learn how to prepare for the making of products using textiles materials.

A designer must consider how their product may affect others. This can range from how many people are employed in making the product to how people are affected by its use. Obtaining the resources needed to make the product will also have an effect on the environment. By using this book, you will become not only a better, more creative designer, but also more aware of how the products you use affect our society and the environment that we live in.

**Introduction to Textiles Technology**

## Case study

### Textiles and the future

Many new and exciting textiles materials are being developed by scientists every day. Some of these new materials are as strong as traditional woods, metals and plastics, but they are lighter, more flexible and often cheaper to produce. They are used to replace traditional materials in a wide range of products, and textiles materials are now often found in the most surprising places, not just in our homes and clothes.

Textiles materials are used to make replacement arteries and valves that go inside our bodies, and many of these items are knitted – just like the jumper you might be wearing now. Many specialist textiles materials cannot be seen, such as those used to reinforce roads and buildings. We all know that products such as cars use textiles for the seat coverings, but did you know that the outer shell of some cars is made from glass fibre or carbon fibre, both of which are textiles materials? Textiles materials are used to make specialist clothing suitable for extreme conditions, such as extreme cold or heat and exposure to chemicals, as well as bulletproof and stabproof products. 'Intelligent' materials are also being developed that can react to the environment around them.

The future of the different areas of the textiles industry is very exciting. So, when you next think of textiles do not just think of your clothes and home furnishings. Remember, there is a whole new world of textiles materials and products waiting to be designed and used.

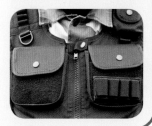

## Making

To turn designs into working products, you will need to know about the materials that could be used to make them. In this book, you will learn about the properties of different materials, including their advantages and disadvantages. You will find out how different processes can be safely used to make a finished product. You will also learn about how products are made in industry.

## ....and finally

Textiles Technology is an exciting and very rewarding subject. It will involve you in a great deal of decision-making and practical work. You will need to plan ahead and become very organised. In the end, you will have developed a wide range of knowledge, skills and understanding. This will be very useful to you over the coming years, and hopefully you will have designed and made some products that you can be really proud of.

# Chapter 1    Deciding what needs to be made

## 1.1 Reasons for product development

### Objectives

- Be able to explain what is meant by 'design process'.
- Be able to identify a need that a product is designed to meet.

### Key terms

**Design process:** a sequence of activities carried out to develop a product.

**Need:** what the product you are designing must do.

**Want:** features that you would like the product to have.

## The design process

When you are designing a new product, there are a number of things that need to be done to create it. For example, you need to decide what is needed, how to make it and, after making it, test it meets the needs. One way of showing these activities is as a series of tasks. This is referred to as the design process.

In practice, the design process is often not carried out in sequence. As you go through it, you find out more about the final product. This can change what was needed in an earlier step. For example, you might find that you do not have the materials you wanted to use. This might mean that you have to change your design. Sometimes you may have to jump back to earlier steps several times during the process.

## Identifying the need

The first step in the design process is to identify the need. The need is what the product you are designing must do.

One way to do this is to write down a problem. If you turn this into a positive statement it becomes the need, as in Figure B. The more general the need is, the more chances this gives the designer to come up with a really creative or unusual solution.

It is important to separate needs from wants. A need is something that the product **must** do. A *want* is something that is nice to have, but the problem could still be solved without it.

## Needs and designing products

A single product might have to meet several different needs. For example, a toy for a small child may have to be educational, safe and low cost. Sometimes needs contradict each other. This means that meeting one need makes it harder to achieve one of the other needs. For example, the toy may also need to be very strong. However, because it needs to be low cost, this might stop the designer using the strongest material. When needs contradict each other, at some stage in the design process the designer will have to make a decision about which need is more important.

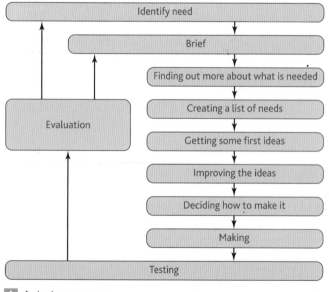

**A** A design process

Chapter 1 Deciding what needs to be made

Another important point about needs is that they can change. This may be due to changes in society, the way we live our lives, or to developments in technology. For example, for many products it has become a need in recent years to use recycled materials to reduce damage to the environment.

## Case study

### Backpack

A backpack is one solution to the need to be able to carry large pieces of equipment around on your back while travelling on foot.

Backpacks are also known as rucksacks or knapsacks. This type of bag is designed to carry heavy weights for long periods of time on the body. Large backpacks are designed so that most of the weight is placed around the waist area by means of a heavily padded belt. The shoulder straps then act as a means of keeping the weight stable and balanced, making it easier for the person carrying the backpack.

Many years ago these backpacks would have been used to carry tools or game (small animals and birds) that had been caught to eat. The animals would be quite heavy to transport home so they were wrapped and carried in a backpack.

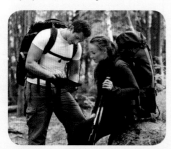

Nowadays, backpacks are often used by walkers to carry equipment. They can hold items such as clothes, sleeping gear and tents. Soldiers use backpacks to carry all that they need on their mission, including tents, food and weapons.

Can you imagine how our needs and wants may change again in the future, and how backpacks may develop in response to this?

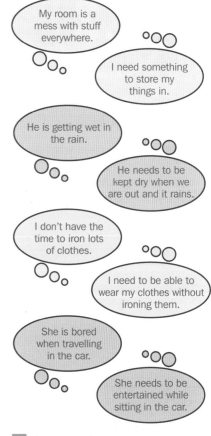

*My room is a mess with stuff everywhere.*

*I need something to store my things in.*

*He is getting wet in the rain.*

*He needs to be kept dry when we are out and it rains.*

*I don't have the time to iron lots of clothes.*

*I need to be able to wear my clothes without ironing them.*

*She is bored when travelling in the car.*

*She needs to be entertained while sitting in the car.*

**B** Examples of problems and needs

### Summary

- The design process is the series of activities that are carried out to create a product.
- The first step in the design process is to identify the need.

### Activities

1. Make a list of items that you have used today that are made from textiles – for example, the clothes you are wearing, a bag you are using, or furnished chairs you sit on, such as a sofa or car seat. For each item, identify the needs that it was designed to meet.

2. Different users have different needs. For example, a teenager and an older person will probably want something designed quite differently.
   - Choose three extremely different users, such as a toddler, a teenager and an older person.
   - List the needs for each user for a bag to carry their basic items throughout the day.
   - Using your list of user needs design a suitable bag for each of the users.

# 1.2 Understanding the design brief

## Objectives

- Be able to explain what a design brief is.
- Be able to write a design brief.

## What is a design brief?

After a need has been identified, the next activity is to write the **design brief**. This is a short statement of what needs to be designed.

The design brief is given to the person who will design the product. It is often only one paragraph long. A good brief will state:

- what the product must do
- who will use it
- who may buy it
- the things that limit the design
- some important features of the product.

The example below is a design brief for a child's toy.

### Design brief

There is a need for an educational toy for children aged 3 to 5 years. This would be bought by parents and relatives. It should be suitable to be made as a one-off product. The cost should be similar to other toys that are available in the shops. It must be safe to use. It should be made using sustainable fabrics and components.

*This is the user of the product.*

*This is the need. It is the function that the product must carry out.*

*This is the market for the product – the people who may buy it. Often this is the same as the user of the product, but not always*

*This is a constraint – this means it limits what the designer can do. The designer will have to design the toy so that it can be made with tools that make just one product at a time, rather than big industrial machines.*

*This is another constraint. The designer may have some great ideas that would cost too much to make. He or she would have to reject those ideas and choose one that could be made at a lower cost.*

*This is a good example of an important product feature.*

*This is another important product feature. 'Sustainable fabrics and components' mean natural materials that can be replaced without damaging the environment. For example, this might be organic cotton or recycled fabrics from old garments.*

## Analysing the design brief

The next task is to analyse the design brief. The aim of this is to identify all the information that you need to know to be able to design the product. This involves asking lots of questions about what is needed. Example questions include the following.

Chapter 1 Deciding what needs to be made

- What does the product have to do? How might it do this?
- Who will use it? Who else might be affected by it?
- How will it be used?
- Where will it be used?
- What could it be made from? How could it be made?

You should explore each answer in as much detail as possible. Normally, you will not know all the answers at this stage. However, this analysis tells you what you need to find out in the next step of the design process.

One way to analyse the brief is to create a spider diagram. This starts with the need in the centre. You then make branches for each question about what is needed. Many of these will have further branches off them listing more questions about the detailed needs of the design.

### Key terms

**Design brief:** a short statement of what is required in a design.

**Market:** the group of potential customers who may buy a product.

**Constraint:** things that limit what you can design and make.

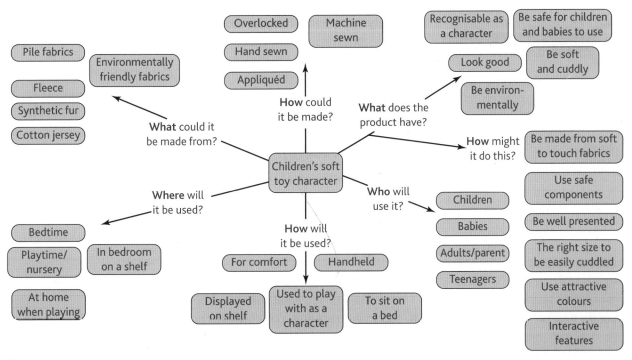

A Spider diagram for a child's toy

### Activities

1. Choose a product that you are familiar with. For example, a small drawstring swimming bag, an oven glove or a sports T-shirt. Write out the design brief that you think was used for this product.

2. This is the design brief for a product.
   The need is for a container to hold and protect a mobile phone. It would be used by most people to protect their phone and to show who it belongs to. It would be made in large quantities and sold at a very low cost. It should be made from recycled materials. It should have a theme based on a favourite sports team.
   Analyse this brief using a spider diagram.

### Summary

- A design brief is a short statement of what is required. It should state the user, the market, any constraints and any important features of the product.
- The aim of analysing the design brief is to identify what you need to know to be able to design the product.

# 1.3 Research

## Objectives

- Be able to explain the purpose of carrying out research.
- Be able to identify a range of different research activities.

 **Link**

See **1.2 Understanding the design brief** for more on analysing the design brief.

### Key terms

**Research:** gathering the information you need to be able to design the product.

**Primary research:** finding out the information you need by yourself.

**Secondary research:** finding out the information you need by using material that someone else has put together.

## Why do research?

The purpose of **research** is to gather the information that you need in order to be able to design the product. This means that you need to know what information is required. You will probably have identified this from your analysis of the brief.

The research you carry out should be relevant and analysed.

- **Relevant** means that you should only investigate the things that you need to know.
- **Analysed** means that you should draw conclusions from your research. The analysis explains what that piece of research means for your design.

*For example, there would be no point investigating the properties of knitted fabrics if you have to make your product out of a woven fabric.*

*For example, each piece of research could be finished with a statement that starts, 'As a result of this, I have decided that my product …'*

## Types of research

There are two types of research: primary and secondary. **Primary research** is where you find out the information needed yourself. **Secondary research** is where you use material that someone else has put together. For example, if you were investigating how to make your product:

- primary research could include testing different manufacturing processes to see what they can do
- secondary research could include using books or watching videos to find out about the processes.

Primary research normally takes more time than secondary research. It can be much quicker to read about something than to carry out tests to find it out. However, primary research can be focused exactly on the product and information that you are investigating. Secondary research can be very general in nature, although it may still be able to give you the information that you need.

### Primary research

Some examples of primary research are:

- using questionnaires to ask users what they want your product to do or to look like
- testing different fabrics to find out their properties
- taking existing products apart to find out how they are made.

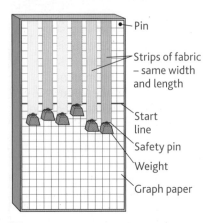

A  Testing the strength of a fabric

## Secondary research

Some examples of secondary research are:

- looking up fabric properties in a textbook
- visiting exhibitions and museums
- using images from magazines or the internet to make a mood board.

## Questionnaires

A questionnaire is a list of questions. It is primary research that is used to find out the needs and wants of the people who will use the product. Ideally, as many users as possible should answer the questionnaire. This helps to make sure that the design will be suitable for lots of people.

Questionnaires normally start by asking whether the person answering is likely to use the product. They might ask about their age, gender and whether they use the type of product being designed. They will then ask a series of questions about each piece of information needed, for example, which colour the person likes, how much they might pay for the product, and so on.

For each question they ask, there will normally be a choice of possible answers. This means that it is easy to plot the answers on to bar graphs or pie charts. These visual tools can help with the analysis.

### Link

See http://store.nike.com

### Activity

1. A company that makes trainers is thinking about designing a new casual trainer for teenagers. They need to know the following.
   - What fabrics the users would prefer for the trainer.
   - What colour the trainer should be.
   - What other features the trainer might have.
   - How much teenagers would be prepared to pay for a pair.

   a Design a questionnaire that will get the answers to their questions.

   b Get 10 people to complete the questionnaire.

   c Produce some charts showing your results.

   d Explain what your findings mean for the trainer design – what fabrics should be used, what colour, and so on.

### Questionnaire

Hi, my name is Mike Lloyd and I am going to design and manufacture a portable chessboard that's appealing to the teenage eye. I would be very grateful if you answer a few of my questions.

1. How old are you? (Please tick)
   13-14 ☐  15-16 ☐  17-18 ☐  19+ ☐

2. What gender are you?
   Male ☐  Female ☐

3. How often do you play chess?
   Every day ☐  Weekly ☐  Monthly ☐  Hardly ever ☐

4. What size would you want the chessboard?
   Palm size ☐  Lap size ☐  Desktop size ☐

5. The chess board will be able to compact itself. How would you like it to compact?
   Fold down middle ☐  In a box ☐  Roll up into tube ☐
   Draws for the pieces ☐  Inflatable ☐  Other ....................

6. Which material(s) would you like it to be made out of?
   Wood ☐  Glass ☐  Metal ☐  Plastic ☐  Rubber ☐

**B** Example of a questionnaire

### Summary

- Research is gathering the information that you need to be able to design the product.
- Primary research includes questionnaires, testing fabrics and examining existing products.
- Secondary research includes using books and the internet, and collecting images to make a mood board.

# 1.4 Product analysis

## Objectives
- Be able to carry out a product analysis of a product.

Normally, there will already be products that fill similar needs to the one that you are designing. You can use these products as a source of information to help you design your product.

**Product analysis** involves investigating existing products. It is not just about describing them. It is about understanding why they are designed in the way they are. If you can identify the good features of the product, you may be able to use these in your own design. If you identify ways that the product can be improved, this may allow you to create an even better product.

## ACCESS FM

ACCESS FM is a way of remembering what you should investigate when analysing a product. Each letter stands for a different thing you should analyse.

| | |
|---|---|
| **A**esthetics (how the product appeals to the five senses) | • What colour is it? What shape?<br>• What texture does the surface have? Smooth or rough?<br>• Does the product look attractive? Why? |
| **C**ustomer | • Who might use the product? Why would they use this rather than another similar product? |
| **C**ost | • How much does it cost to buy? Is it good value? |
| **E**nvironment | • Is it environmentally friendly?<br>• Is it made from recycled materials? Can it be recycled? |
| **S**ize | • What size is it? How long, wide and tall is it? (Hint: measure it and write down the sizes!)<br>• Why is it this size? If the size was made bigger or smaller, would the product do its job better? |
| **S**afety | • How has the user been protected from harm when using it? Are there any sharp edges, small parts that could be swallowed, loose parts, etc.?<br>• Does the product meet recognised safety standards and regulations? How do you know? |
| **F**unction (what the product is designed to do) | • What will the product be used for? How would it be tested to make sure it is suitable? How could it be improved to make it work better?<br>• Where will it be used? |
| **M**aterials and Manufacture | • What materials is it made from? Would different materials work (or look) better?<br>• How was it made? Why was it made in this way?<br>• If it has different parts, how were these joined together? |

Chapter 1 Deciding what needs to be made

## Case study

### Baby/toddler fabric book

This is an example of a product analysis for a baby/toddler fabric book.

| | |
|---|---|
| **Aesthetics** | The book uses lots of bright colours, so that children will find it interesting to look at. It has brightly coloured animal characters that children will identify with. |
| **Customer** | It would be used by small children aged less than 3 years. It would be bought by their parents. |
| **Cost** | The cost of this book is about £10–£15, so that it is about the same cost as other baby/toddler books for children of this age. |
| **Environment** | The book is made from organic cotton — it can be recycled easily owing to the natural fabric used, and is a sustainable source, as more cotton can be grown. |
| **Size** | The pages of the book are that size so that they fit easily into a child's hand. The pages are made of fabric, making it easy for a baby or toddler to grip it. |
| **Safety** | It has no sharp edges or parts, so children can't cut themselves on it. All the parts that can be taken off are quite big, so that no one can choke on them. |
| **Function** | The book has removable soft characters that can be attached to other pages using Velcro. The characters can be used to help illustrate the story and allow the child to interact with the storytelling, helping to make reading fun. |
| **Materials and manufacture** | The book is made from different coloured dyed and printed fabrics. The book has been constructed using a sewing machine and printing methods, including sublimation printing and surface block printing. It was probably made using computer-controlled machines, because lots are made and they are all the same size. |

## Remember

It is important to say **why**.

A great feature of the product analysis shown in the case study is the use of '… so that …' or '… because …', which lead into an explanation of why the product is the way that it is.

## Key terms

**Product analysis:** investigating the design of existing products.

**Aesthetics:** how something appeals to the five senses.

**Function:** the task that a product is designed to do.

## Activities

1. Carry out a product analysis of your bag.
2. Examine the product analysis in the case study. What extra information or explanations could have been included to make it better?

## Summary

- Product analysis is about understanding why existing products are designed the way that they are.
- ACCESS FM is a way of remembering the things to investigate during a product analysis.

9

# 1.5 Specification

## Objectives

- Be able to explain what a specification is.
- Be able to create a specification.

## What is a specification?

The **specification** is a list of all the needs that the product must meet. Most of the needs in the specification are the answers to the questions identified when the design brief was analysed.

The specification is one of the most important documents created during the design process. It is used to tell us what can and cannot be done when designing the product. If any important needs are missed out from the specification, the product you design might not do what users need it to do, or you might not be able to make it.

**Link**

See **1.2 Understanding the design brief** for more on analysing the design brief.

## Constraints

It is especially important that any **constraints** are listed in the specification – these are things that limit what you can design or make. For example, if you only had cotton available, this would be a constraint. In which case, it would be wrong to design a product that had to be made from silk. Not all the needs in the specification will be constraints. Some will be features that users might want, or things that are needed for the product to carry out the things it has to do.

**Link**

See **1.4 Product analysis** for more on ACCESS FM.

## ACCESS FM

A good specification for a simple product might list around 10 needs. Similar to carrying out a product analysis, ACCESS FM can be used to make sure that you have included all the different types of needs in your specification.

| **A**esthetics | What shape is it? What colour is it? What is the surface texture like? |
| --- | --- |
| **C**ustomer | Who is it being designed for? |
| **C**ost | How much should it cost to make? |
| **E**nvironment | Should it be made from recycled materials? Must it be able to be recycled? |
| **S**ize | What size is it? (Hint: write down the sizes. For example, 'it must be less than 50 mm long' or 'it must be between 40 and 60 mm wide'.) |
| **S**afety | What things must be included in the design to protect the user from harm when using it? Does it have to meet any safety standards and regulations? |
| **F**unction | How will it be used? |
| **M**aterials and manufacture | What materials can it be made from? What processes have to be used to make it? How are the parts joined together? |

Chapter 1 Deciding what needs to be made

The specification will be used many times during later stages in the design process, as in the examples below.

- If there is a choice of possible designs, they might be compared against the specification to see which one is the best.
- When the final product has been completed, the design will be compared to the specification to check that it does what it is needed to do.

It is a lot easier at those stages if the needs in the specification can be tested. The result of the testing might be a yes/no answer, or it might be a measurement.

> **Key terms**
>
> **Specification:** a list of needs that the product must meet.

## Case study

### Educational toy for a child

This is an example of a specification for a baby/toddler book.

1. The product should be a soft fabric book. — These are aesthetic needs and functional needs, explaining what it is needed to do. Many specifications start with the functional needs
2. It should have removable characters that can be placed on to different pages in the book.
3. It should be brightly coloured, with red, blue, yellow, green, purple and orange. — This is an aesthetic need
4. It should have a soft, smooth finish that can be easily cleaned. — This is both an aesthetic need and a safety need
5. It should be suitable for use by children aged 0 to 3 years. — This is the user
6. The cost of the materials used to make it must be less than £10. — This is a cost need. It is better to give a range ('less than' or 'from… to…') than an exact value
7. It must be made of organic cotton from a sustainable source. — This is both an environmental need and a materials need. The word 'must' also shows that it is a constraint
8. The book should fit into the hands of the children who use it. — This is a size need. It would have been better to write in the range of sizes
9. It should have no sharp edges.
10. It should have no small parts that may be swallowed by a child. — These are safety needs
11. It must be able to be made as a one-off product using hand tools.
12. The fabric pages should be constructed using a sewing machine and printing methods. — These are manufacturing needs

## Activities

1. Create the specification that you think might have been used for a garment you are wearing. For each need, include a sentence explaining why it is important.
2. Examine the specification in the case study. For each of the listed needs, write down why they could be important. What extra details could have been included to make it better?

## Summary

- A specification is a list of needs that a product must meet. It should include any design constraints.
- ACCESS FM can be used to check that you have covered all the different types of need in your specification.

# Chapter 2 Sustainability

## 2.1 Environmental concerns

### Objectives
- Be able to explain why products have an impact on the environment.

Our environment is the world we live in. We are used to a certain 'quality of life', where we have food, shelter and the many comforts that we use to improve our lives. These include, for example, fashion, phones, television, computers and air travel. To make sure that our standard of living stays at least as good in the future as it is now, we need to protect our environment from being damaged too much by what we do.

## How products affect the environment

We use lots of different products every day. However, we do not often remember that **every** product made has an effect on the environment.

### Materials

Products are made from materials. Most materials are **non-renewable**. This means that there is only a certain amount of that material on our planet, and as we use it, there is less of it left to use. If a type of material starts to run out, then it normally becomes more difficult to obtain and more expensive to buy. This makes it more difficult to use that material, and the properties it has, in products.

A Oil is a non-renewable resource used to make textiles

The materials you can see in a product are normally not the only materials that were used when making it. There is often waste. For example, if a pattern was cut from a length of fabric, the fabric left over from around the pattern will be waste.

Materials will also have been needed to make the machines or tools that were used to manufacture the product, the vehicles used to transport it from the factory to the shops, and the packaging used to protect it.

### Energy

Energy is needed to power the machines which are used to make products, and the vehicles which are used to deliver them. Currently, most of this energy comes from burning non-renewable materials, such as oil or coal. Being non-renewable means that these resources will eventually run out.

B Wind power generators

In the future, it is likely that more and more of our energy will be generated by using sources such as wind power, solar power or the sea (tidal power). These are renewable sources, which means that they will not run out.

## Pollution

When oil or coal are used to make energy, they do not just make energy – they also make chemicals and gases at the same time. These include carbon dioxide, which is a cause of global warming. If these by-products escape into the environment, they can cause pollution.

In a similar way, making products from some materials can produce unwanted by-products, such as waste chemicals, especially when dyeing and printing fabrics.

## Using products

Some products can contribute to pollution by the way that they are used. For example, washing clothing at high temperatures can use more energy and use up valuable energy sources. Selecting fabrics and designing garments that can be easily cared for, and washed at low temperatures, means that they use less energy and have less of an impact on the environment.

Pollution can also be caused by throwing away products after we have finished with them. Some fabrics require harmful chemicals to break them down in order to dispose of them. By recycling fabrics, and using fabrics that break down naturally, we can put less stress on landfill sites and avoid causing further pollution.

## How can designers make things better?

When a product is designed, it is important that every way in which it might affect the environment is considered: from making, to use, and then disposal. Designers need to consider the six Rs, which are explained in **2.2 The six Rs** and **2.3 The six Rs continued**.

Where possible, a designer should think about using sustainable materials. These are materials that have less of an impact on the environment. For example, lyocell is one of the most environmentally friendly fibres, as every aspect of its manufacture is completely renewable. Lyocell is a regenerated cellulose fibre made from wood pulp.

C  A lyocell garment

### Key terms

**Non-renewable:** something that is not replaced and will eventually run out.

**Pollution:** contamination of the environment.

**Sustainable materials:** materials that have less of an impact on the environment.

### Summary

- Every product made has an effect on the environment.
- Making products uses materials, both for the product itself and the waste produced when making it.
- Making products uses energy. This is often obtained from non-renewable resources.
- Pollution might be caused as a result of the by-products of making or disposing of a product.

### Activities

1. Clothing can feature printed designs or bright colours, and often comes packaged in cardboard and plastic. Produce a word web that analyses all the different ways that this product might affect the environment.

2. Choose a product that you are familiar with, such as a bag or item of clothing. Write an article for a magazine that explains all the ways that the product might affect the environment.

3. Take a garment that you are familiar with, and list all of the things you could change about it to make it more environmentally friendly. Think about how it is made and packaged, as well as what it is made from.

# 2.2 The six Rs

## Objectives
- Be able to list the six Rs.
- Be able to explain what is meant by reduce, rethink and refuse.

Products are made from parts, or components. In an ideal world these parts would all be made from **sustainable materials** such as wool, lyocell or cotton. Unfortunately, for many products those materials are not suitable. One compromise is to use as little new non-sustainable material as possible.

The six Rs are a list of approaches that can be used to make sure the smallest possible amount of new materials are needed for the product.

A Wool is a sustainable material

B Cotton is a sustainable material

### Case study

#### How the six Rs could be considered when designing a pair of trainers

**RECYCLE** The materials that are used may be recycled – at the end of the trainers' life they may be taken apart and recycled, and used to make more new trainers.

**REPAIR** Most trainers can be repaired, but most people just buy a new pair. It would be far cheaper to repair a pair of trainers than to buy a brand new pair.

**REUSE** Old trainers could be reused by taking them apart and reusing the components that are still in a good state. For example, the air cushioning in this trainer is enclosed inside the sole and could be reused if it has not been punctured.

**REDUCE** Using fewer materials can make the trainers cheaper. It can also make them weigh less, so less fuel is used when they are transported to shops.

**REFUSE** Customers may choose not to buy trainers that are just fashion accessories and that serve no real function for sport or exercise.

**RETHINK** Designers might decide that different types of materials can be used, such as recycled materials rather than new ones. Users might question whether they need a fashion pair of trainers if they are not required for a specific sport or function.

The first three of the six Rs are focused on getting the most effective design for the product. These are the best approaches because they mean that you need less material for the product. Recycle, reuse and repair are about making sure that once you have a product, you make the most of the materials that have already been used and processed.

## Reduce

**Reduce** means designing the product so that it uses fewer raw materials. For example, this might mean creating a sample of the product, known as a **toile** or **mock up**. From this you could calculate exactly how much material is needed, and this would help to reduce wastage. Reduce could also mean making a smaller product. For example, a long full skirt could become a shorter, more fitted skirt that would naturally use less fabric.

## Rethink

**Rethink** means reconsidering all the things about the product to see if it could be made more environmentally friendly. For example: is the product really needed? Could it be designed in a different way so that it uses less material? Does it need to look the way it does? Does it need to be packaged the way it is?

## Refuse

**Refuse** means not accepting things that are not the best option for the environment. For example, this might mean refusing to use extra packaging just for its appearance. It might also mean not accepting that the easiest way of disposing of the product, once you have finished with it, is the best way.

> **Link**
>
> See **2.3 The six Rs continued** for more on recycle, reuse and repair.

> **Key terms**
>
> **Reduce:** reducing the amount of raw materials needed.
>
> **Toile** or **mock up:** a sample product used to test out a design, made from cheap, thin material such as muslin or calico.
>
> **Rethink:** reconsidering the design of the product.
>
> **Refuse:** not accepting things that are not the best option for the environment.

> **Activities**
>
> 1. Think about an umbrella that will be used when it is raining:
>    - Create a sketch of a similar umbrella that **reduces** the amount of material used.
>    - **Rethink** the umbrella – is there another way of allowing people to keep dry in the rain? Create some labelled sketches with your ideas.
> 2. Make a list of any packaging that you have used in the last day – this could include food wrappers, boxes and bags. For each item on the list, write down an alternative that could have been used instead if you had **refused** to use it.

> **Summary**
>
> - The six Rs are reduce, rethink, refuse, recycle, reuse and repair.
> - Reduce means using less material.
> - Rethink means reconsidering all aspects of the design.
> - Refuse means not accepting things that are not the best option for the environment.

# 2.3 The six Rs continued

## Objectives

- Be able to explain what is meant by reuse, recycle and repair.
- Be able to give an example for each of the six Rs.

The best way of using the least possible amount of non-sustainable materials in a product is through design. This involves applying the first three of the six Rs: reduce, rethink and refuse. Once the product is made, you can make sure that the least possible amount of new materials is needed by applying the remaining three of the six Rs: recycle, reuse and repair.

## Recycle

**Recycling** means that you take the material in a part, break it down, and use the material to make a new part. Recycling can be carried out for most types of fabrics, and many products can be recycled into textile fibres, including some plastics. Products containing materials that can be recycled are often marked to show the material they are made from.

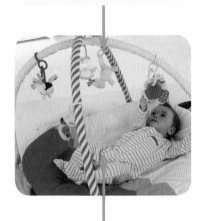

The baby toys on this play gym have been designed to be removable, both for interest, and so that they can be replaced if damaged or lost.

Rather than be glued together, the battery unit is held together by screws, so it can be opened up to replace broken parts or batteries.

**A** The need for repair has to be considered during the design of a product such as a baby musical play gym

### Case study

#### Plastic bottles and polar fleece

Disposable plastic water bottles are designed to be used over and over again (reuse). They are designed to be lightweight so they use as little material as possible (reduce). The material used can be recycled (recycle) into many different products, including textile fibres!

Many of the water or drinking bottles you use are made from a plastic called polyethylene terephthalate, otherwise known as PET. This type of plastic can be recycled into PET fibre, which is then used to create polar fleece.

Polar fleece is a soft, warm and lightweight material used for making clothing for sporting and outdoor activities. It is ideal for this purpose, as it has great insulating qualities as well as allowing perspiration to pass through it easily. Other benefits are that the material is machine washable, dries quickly, and can be recycled again into other polar fleece products.

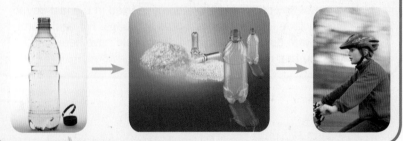

It is easiest to recycle products that are made from only one material. Unfortunately, many products are made up of lots of different parts and materials, which means that they need to be taken apart to allow recycling. It can sometimes cost more to do this than it costs to make new material, but it is better for the environment.

## Reuse

**Reuse** means using the part again. This is better than recycling, as it is not necessary to use energy to change the shape or size of the part. For example, people buy second-hand or vintage clothes. This is because it is cheaper to buy clothes second-hand than to buy them new. Second-hand clothes are often sold through charities so they have the added benefit that the proceeds will also go towards helping others. Vintage clothing is older, and usually of classic design, well made and very desirable. Unfortunately, it is usually more expensive too.

## Repair

**Repair** means mending parts so that they will last longer. This means that less new materials are needed to make replacement parts. For products such as coats and jackets, it is much cheaper to replace missing buttons than buy a whole new coat!

Product is made from aluminium and can be recycled

Product is made from glass and can be recycled

Product contains plastic materials that can be recycled

Product contains a certain type of plastic that can be recycled, indicated by the number and letters

**B** Meanings of recycling symbols

### Activity

1. Many textile products can be redesigned using the six Rs.
   - In pairs, choose a textiles product, such as a garment you are wearing or your bag.
   - Draw the garment or bag and fully label it, including all the fabrics and components.
   - Write out the six Rs: reduce, rethink, refuse, recycle, reuse, repair.
   - Next to each, write down how the garment or bag could be redesigned using these points.
   - Now redraw the garment or bag using your new six Rs criteria. Fully label your garment or bag.
   - In pairs, report back to your class how your garment or bag could be more environmentally friendly by using the six Rs.

### Key terms

**Recycling:** breaking or melting down the material so that it can be used in a new product.

**Reuse:** using the product again.

**Repair:** mending a product so that it lasts longer.

### Summary

- Recycle, reuse and repair are about using the least amount of new non-sustainable materials used.
- Recycling involves breaking the material down and making it into a new product. Not all materials and products can be recycled.
- Reuse means that the product is reused without needing to break it down.
- Repair increases the usable life of a product.

# Chapter 3    Design influences

## 3.1 Social and cultural issues

### Objectives

- Be able to give examples of how social and cultural issues may affect the design of a product.

Designers do not *just* think about the product they are designing. They also have to make **moral choices** about a wide range of issues. They have to think about what is 'good' and what is 'bad' for society, and how this will affect the design of the product.

How they decide this depends on the values of society and on the market needs, such as cost. There is often no 'correct' answer and it comes down to a moral judgement.

## Social influences on design

### Do we design for everybody or just certain people?
If products are designed only for the 'average' user, many members of society may find it difficult to use them, as in the following examples.

- If clothes are only available in average sizes, then tall and short people might struggle to get clothes to fit them.
- Due to advances in health care, society is now made up of more and more elderly people. They often find it difficult to unfasten garments that have stiff buttons and button holes. Trousers designed for the elderly often have an elasticated waist to help with this problem.
- Young children cannot always master a zip, so using Velcro is one alternative that could be considered in children's clothing and toys.

Many of these issues can be addressed through thoughtful design. However, sometimes this has an effect on the cost of the product or how well it works.

### Do we make it environmentally friendly?
Sustainable materials sometimes cost more than non-sustainable materials. Similarly, it may cost more to design and make a product so that it can be easily recycled once users have finished with it. However, some people may buy a more expensive product if they know it is more environmentally friendly.

### Do we use machines to make it?
Everyone wants cheap, good-quality products. Some products are designed to be made by computer-controlled machines, as these machines can make things cheaper than human workers. However, this means that fewer people are employed.

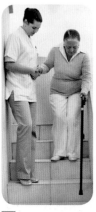

**A** Elderly people find getting dressed more difficult as they get older, they need clothing that is comfortable, and easy to use

### @ Link

See **2.1 Environmental concerns** for more on sustainability.

### Key terms

**Moral choices:** decisions about what is good or bad.

**Culture:** how beliefs, history and traditions have influenced a group within society.

## Where do we make it?

Another way of making products cheaper is to make them in countries where workers get very low wages. In these countries, the conditions for workers are sometimes far below those accepted in the UK. There may also be more pollution from transporting goods all over the world. The use of the Fairtrade logo helps customers to identify those products that safeguard against this.

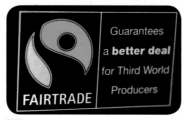

**B** The Fairtrade mark

## Cultural influences on design

**Culture** is the way that beliefs, history, tradition and lifestyle have influenced a group of people. This varies between societies, or even between different groups within a society. It has a big influence on the products the people in that group use.

For example, in China the colour red means good fortune. However, in South Africa it is the colour of mourning. Trying to sell the same red product in those two countries may get a very different response!

### Case study

**Marks & Spencer**

Marks and Spencer (M&S) are a well-known high street brand known for providing good-quality clothing, household goods and food. Like many large companies, they have recognised a need to help to protect our environment, and take on a moral and ethical responsibility for the way that they trade and manufacture goods. In January 2007, M&S introduced Plan A with the aim of becoming the world's most sustainable retailer. Some of the sustainable products on offer from M&S include, organic cotton clothing, and bedding, Tencel clothing, and bedding made from recycled fabrics. M&S change their ranges frequently, so take a look at what products they are currently promoting that support sustainability and the environment.

- Think about a large company, that is a well-known brand, and research it to see what they are doing to help the environment or trade ethically.
- Write a letter to the company you have chosen, advising them on what they could do to further improve on this.

### Activities

1. Examine your school bag. Write down a list of all the moral issues that the designer may have had to consider when designing it. What decision do you think was made for each issue? Explain your answers.

2. Consider now that your bag is being made for a wheelchair user. List the issues that may be raised in designing for this user. Has this user been excluded in the design of your bag?

### Link

See **http://plana. marksandspencer.com/ about** for further information.

### Summary

- Designers have to make moral choices about how social issues affect the design of their products. These choices will depend on the values of society and market influences, such as the acceptable cost.

- Social issues include how the product affects other people, the environment, employment and manufacturing location.

- Culture can have a big influence on the products that a society may use.

# 3.2 Laws and standards

## Objectives

- Be able to explain the role of laws and standards during the design of a product.
- Be able to explain the role of a patent.

## Making products safe

Society needs to protect people from being harmed by dangerous or faulty products. It does this through laws and standards. The designer has to take these into account when designing a product.

### Laws

There are laws to protect people from being injured by products. There are also laws to stop people from being sold products that do not do what they are supposed to do. If a designer or manufacturer breaks these laws then they can be taken to court and prosecuted.

The laws include:

- The **Sale of Goods Act**. This states that goods must be fit to do what they are intended to do. For example, a shop could not sell raincoats that dissolved in the rain!
- The **Trade Description Act**. This makes it illegal to say that the product will do something that it cannot do. For example, you could not claim that a red T-shirt was black, or that its logo glowed in the dark if it did not.
- The **Consumer Protection Act**. This stops people selling products that may be harmful or defective. For example, take the case of a teddy bear for small children, with plastic stick-on eyes. If the eyes could come off and be swallowed, it would be illegal to sell it.
- The **Consumer Safety Act**. This allows the government to ban the sale of dangerous products.

### Standards

A **standard** tells you what properties a certain type of product should have. For example, it might say: 'it should have a strength of more than…' or 'the size should be between …' The standard will also normally tell you how these properties should be tested.

There are thousands of standards covering a wide range of different types of product. In the UK, standards are published by the British Standards Institution (BSI). If a product meets the needs of the relevant standard, it can be awarded the BSI Kitemark (Figure **B**). There are also European Standards. Products that meet these are also marked with a symbol (Figure **C**).

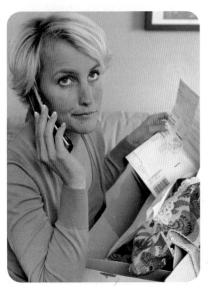

**A** A customer complaining

**B** The BSI Kitemark

**C** The 'CE' marking symbol

Chapter 3 Design influences

## Protecting the designer's work

There are also laws that protect designers and companies by making sure that their ideas cannot be stolen.

A **patent** is a legal protection that gives exclusive rights to the use of a design. This means that only the person who has the patent can use that design idea. Other people cannot use it without the permission of the patent holder. Sometimes they have to pay a fee to get this permission. Patents normally last for 20 years.

Patents help designers by making sure that they get the benefit from their ideas. However, when you are designing a product, you also have to make sure that you are not using features or ideas that someone else has patented.

> **Key terms**
>
> **Standard:** a document, published by an accredited standards agency, which lists the properties expected of a product and the tests that should be carried out to test those properties.
>
> **Patent:** a legal protection for a design idea.

### Case study

#### Waterproof fabric

The now very famous raincoat, 'the mackintosh', was named after Charles Mackintosh, a Scottish chemist and inventor. Until 1823 there had not been a successful method of waterproofing fabric. Mackintosh discovered a way to do this, and patented the process. His invention became the first practical waterproof fabric, and was used to make raincoats.

The waterproof fabrics were used by the British Army, the general public, and even those who took part in the Arctic expedition led by Sir John Franklin in 1924.

Can you think of any other textiles products with unique features that the designer might have patented?

C Woman wearing a modern-day 'mackintosh' coat

### Activities

1. Your family has bought a hammock to use in the garden. The first time someone got into the hammock it came away at the seams and the person nearly fell out! Write a letter to the manufacturer explaining why they should give you your money back, referring to the relevant laws.

2. Patents are often listed on products, along with their reference number. Examine several products and identify those that are protected by patents, or that have British Standard Kitemarks and CE marks.

### Summary

- Designers have to think about laws, standards and other designers' patents when they are creating their designs.
- Standards list the properties expected of a product and how they should be tested.
- Patents give legal protection to a design idea, to stop people using the idea without the designer's permission.

# Chapter 4 — Presenting design ideas

## 4.1 Presenting and developing ideas

### Objectives
- Understand how to develop your ideas.
- Consider the impact that good presentation can have on your designs.

In the world of design, how a product looks is just as important as its function. Developing a product that looks great and works well is not always easy. It is important to be creative with your ideas and also present your ideas in an interesting and professional way.

### Developing ideas

Your ideas are, in some ways, the most important part of the design journey. Once you have an idea it can be difficult, when asked to develop that idea, to know what you do next. The key is to let your **creativity** flow and to '**think outside the box**'.

'Thinking outside the box' really means not making obvious choices, and experimenting until you come up with a good idea.

The following strategies may help you to develop an idea that you have.

- Share your ideas with other people in your class. Ask them to comment on your work and write down what they suggest. Try redesigning your idea with the advice you have been given.
- Put a sketch of your idea in the middle of an A4 page. Pass the design to someone else and ask them to develop the idea further in one of the corners of the page (only give them four minutes to do this). Keep passing your idea on until you have four developments of your original idea. Their ideas might give you a fresh approach to developing your own.
- Choose a word that is completely unrelated to your product, such as 'bouncy' or 'fizzy'. Try redesigning your idea with this word in mind. It should help you to see your product in a different way.
- Use SCAMPER. Using this method means that you ask questions of your design idea that you may not have considered before.

### Activities

1. Follow the bullet points below to develop a design idea of your own.
   - Take one of your design ideas and work through the suggested design development strategies.
   - Look at the case study featured here, and write down what is interesting about Alessi's approach to designing products. Using this approach, try to redesign one of your own ideas.
   - Choose a final design. Present it firstly by hand, and then using a computer to help improve the presentation of your idea.
   - Working in pairs, present your ideas to each other and ask for feedback on what you could improve further.
2. Analyse how this exercise has helped you to develop your design ideas.

| | |
|---|---|
| **S**ubstitute | • What could be used instead? |
| **C**ombine | • What can be added? |
| **A**dapt | • How can it be adjusted to suit a condition or purpose? |
| **M**odify | • How can the colour, shape or form be changed? |
| **P**ut to other use | • What else can it be used for, other than the originally intended purpose? |
| **E**liminate | • What can be removed or taken away from it? |
| **R**everse or **R**earrange | • How can it be turned round or placed opposite its original position?<br>• How can the pattern, order, or layout be changed? |

# Presenting your ideas

Presenting your ideas is important. It is an opportunity to communicate your ideas, and how you do this will impact on the value of your design. If you are good at drawing and graphic skills then you may be happy to present your ideas this way. Always render and annotate (see **4.2 Sketching and rendering**) your final designs, and communicate as much as possible in your presentation. Use front, back and side views to offer visual detail.

If you are not so confident at drawing, then you may want to use a computer to present your design ideas, for example using **Adobe Photoshop**.

### Link

See http://www.alessi.com/en

**A** Fashion drawing created using Adobe Photoshop

## Case study

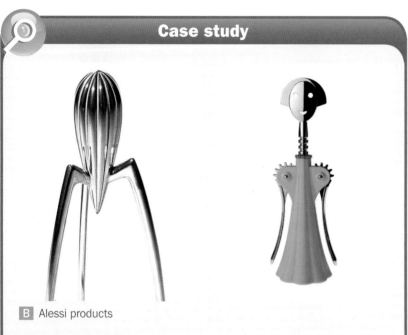

**B** Alessi products

### Alessi products

Alessi began in 1921 and was founded by Giovanni Alessi to develop crafted products for eating and drinking. The business was concerned with giving functional objects a new edge or a fresh approach. They wanted to make people smile at their products as well as want to buy and use them.

The business grew and passed down the family line, and Alessi products are still as popular today as they were then. Their success is largely down to being creative in their design ideas, and developing products that consider form as well as function. They are expert in understanding **ergonomics**, which makes their products easy and pleasurable to use and look at.

- Find some more images of Alessi products. What makes them different to other similar objects with the same function?

### Key terms

**Creativity:** the ability to generate interesting and new ideas and take them from thought into reality.

**Think outside the box:** try to make unusual choices and do not play it safe with your ideas.

**Adobe Photoshop:** a software package that can be used to help develop and present designs.

**Ergonomics:** the science of designing a product to fit the user: for example, an oven glove which perfectly fits a hand.

### Summary

- Creativity and design strategies are important in design development.
- Taking care to present your ideas well impacts on how your ideas are seen and interpreted.

# 4.2 Sketching and rendering

## Objectives

- Be able to explain and use sketching.
- Be able to use rendering to enhance product sketches.
- Be able to produce simple fashion drawings.

## What is sketching?

**Sketching** is a freehand drawing technique. Sketches do not have to be produced to **scale**. They can be two dimensional (2-D) or three dimensional (3-D). 3-D sketches are often used to show the whole design, with 2-D sketches used to show close-up views of details on the design.

The main aims of sketching are to see what your ideas look like and to share them with other people. Sketches are often used to get your first ideas down on paper. This is sometimes known as capturing ideas or producing concept drawings.

The only equipment needed for freehand sketching is a pencil or pen and paper. The sketch should be produced quickly and lightly. However, this does not mean that it is rushed or unclear. If you go wrong, you can either draw over the error or rub it out later.

Sketches should have lots of labels (known as annotations). **Annotations** explain your thinking and help other people to understand your ideas. You might include comments about:

- how the idea compares to your specification
- any design features that are the result of trends or fashion
- how it could be made
- what it could be made from.

## Key terms

**Sketching:** producing a visual image of an idea by hand.

**Scale:** where the size of the design is in proportion to the size of the finished item.

**Annotations:** labels added to a drawing that explain its features and help others understand the ideas.

**Fashion drawing:** a sketch of a figure featuring a fashion garment.

**Rendering:** applying colour or texture to a sketch or drawing.

**Shading:** creating different tones on a sketch or drawing.

## Activity

1. A sports company want to design a new range of sports bags for different sporting activities. Produce a series of quick design sketches. Label all the important features of your ideas.

A Examples of sketches: ideas for a T-shirt designed for the Tate Gallery shop

# Fashion drawing

**Fashion drawing** is not difficult if you know how to do it. The key is to keep your models simple and add the detail and rendering in the products or garments, (Figure **C**). You can trace a simple figure from a picture, then develop the image to create your own fashion drawing. As you become more confident you could add more detail to your figures, or try a side and back view too.

## Steps to produce a fashion drawing

1. Trace the model or figure that you want on to layout or tracing paper using a pen or pencil.
2. Place another piece of layout or tracing paper over the top and draw the garment you want in detail, using thick and thin lines. Layout paper will need light behind it so you can see through it better, so use a light box or window to lean on.
3. You can use the same model several times to create more design ideas.
4. Once you are happy with your design, take another piece of layout paper and trace the whole figure and the product together, using a fine liner pen.
5. Now you can render your fashion drawing to make it look more realistic.

**B** Example of a fashion drawing before rendering

## What is rendering?

**Rendering** means adding colour or texture to a picture. The aim of rendering is to make the drawing or sketch look more realistic, so you can see what it would look like if it was made into a finished product. Two easy-to-use forms of rendering are thick and thin lines, and shading.

A good tip for **shading** is to have two similar colours, such as red and orange, and to use the orange for light areas and to add red for the shaded dark areas.

**C** Example of a rendered fashion drawing

### Activity

2. Using the steps provided in 'Steps to produce a fashion drawing', create a fashion drawing featuring a garment of your choice.
   - Trace off a copy of your fashion drawing and render the garment to make it look more realistic.

### Summary

- Sketches are used to see what your ideas look like and to share them with other people. Important features should be annotated.
- Rendering means adding colour or texture to make a sketch look more realistic.
- Fashion drawings illustrate the features of a garment. They can show front, side and back views.

# 4.3 CAD

## Objectives
- Be able to explain what is meant by CAD.
- Be able to state the main advantages and disadvantages of using CAD drawing software.

## What is CAD?

**Computer-aided design** (CAD) is where a designer uses computer software to help design a product.

Many people make the mistake of thinking that CAD is only about producing drawings. While CAD is very useful for producing drawings, there are also other types of CAD software to help the designer. For example, CAD software can calculate where fabric patterns can be best laid to save on fabric wastage before manufacture. It can even be used to try the design in different colours (Figure **A**). Computers can carry out lots of calculations very quickly, and therefore CAD software can save the designer a lot of time and effort.

## Using CAD for drawing

You will probably have some CAD drawing software in school, such as Techsoft 2D design, Adobe Photoshop or Speed Step (ProSketch and ProPainter).

The basic commands used to create CAD drawings are called drawing tools. Most are activated by using a mouse. These tools range from drawing simple lines and inserting simple shapes, through to copying, manipulating and altering the **features** of the drawing.

When you start drawing using CAD software, it is a bit like drawing by hand. The screen has a working area, a bit like a piece of paper, that you draw on. This area can be changed to almost any size, and you can zoom in to see features close up. However, with three-dimensional (3-D) CAD software you are not limited to just drawing on the paper – you can also draw into the space above and below it! This means that you can create full 3-D models of the item that you are drawing.

**A** A designer uses CAD to design a new collection, trying out different fabric choice and colours

**B** Example of CAD using Speed Step

## The advantages of using CAD for drawing

CAD drawing has many advantages over drawing by hand.

- It can be quicker to create a new drawing as you can copy and edit a similar drawing.
- It is easier and quicker to make changes to a drawing. To make changes to a drawing done by hand you would normally have to restart the drawing from scratch. To make changes to a CAD drawing you can open and edit the existing file.
- Commonly used parts, such as buttons, cuffs and collars, can sometimes be downloaded from libraries of CAD images. This means that they do not have to be drawn, saving lots of time.
- CAD drawings can be more accurate.
- CAD drawings can be saved electronically, so you do not have lots of pieces of paper and files taking up space.
- CAD drawings can be easily circulated to anyone who needs them, using CDs, email or downloads from the internet.

C Students using CAD to draw their designs

## The disadvantages of using CAD for drawing

Although there are many advantages of using CAD for drawing, there are some disadvantages too.

- In industry, CAD software can be expensive, and specialist training is often needed to be able to use it.
- It is harder to keep the drawings safe from competitors, as the electronic files can be easily copied.
- Work can be interrupted or destroyed by computer viruses, corrupt files and power cuts. For this reason, regular backups should be taken of all important files.

### Key terms

**Computer-aided design:** the use of computer software to support the design of a product.

**Features:** details on the design.

### Activities

1. Using the CAD software available in your school, produce a drawing of a fashion garment or bag.
2. Demonstrate the benefits of CAD design by changing the colours of the product you designed in Activity 1. Try presenting your product with a variety of colours and fabrics.
3. A local textiles company makes the latest in sportswear. The range of sports products that they make changes every year, depending upon fashion. The manager of the company has decided that he does not want the cost of buying new CAD software, so he is thinking about getting workers to produce any drawings they need by hand. Write him a letter explaining why this might be a bad decision.

### Summary

- Computer-aided design (CAD) is the use of software to assist in the design of a product. This includes the use of CAD software to produce drawings.
- Compared to drawing by hand, CAD drawings are easier to change, can be more accurate, and are easier to store and distribute.

# Chapter 5 — Preparing for making

## 5.1 Modelling and pattern drafting

### Objectives
- Understand how and why patterns are used.
- Understand the importance of modelling and creating a prototype.
- Understand how CAD can assist in creating and developing patterns.

### Key terms

**Pattern** or **template**: normally a paper or cardboard shape, from which the parts of a product are traced on to fabric before they are cut out and sewn together.

**Commercial pattern**: pattern sold to the public that has already been tried and tested.

**Tailor's dummy**: a piece of equipment that is used to draft patterns and garments on, instead of using an actual person.

**Modelling**: making up a rough version of a product, or parts of a product, and testing them to see if they work.

**Prototype** or **mock up**: the first rough version of a product, which is made up to test the product.

## Patterns

Before you make a textiles product you will need a **pattern** or **template**.

### Pattern drafting

You can make your own pattern – start with simple shapes and progress to more complicated ones once you understand how to do it.

To make a simple cushion, cut a square of paper to create a pattern. Pin the pattern to the fabric you want to use and mark around the pattern. Cut out two pieces of fabric using the pattern, then sew them together to create a cushion.

### Disassembly

By taking a garment apart, you can see the shape of each individual piece, which will show you how it has been put together. If you draw around these parts, you will create a pattern of the separate pieces that go together to make up the garment.

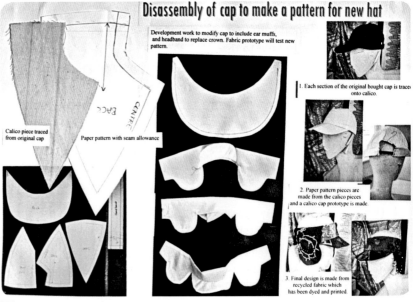

**A** A plain canvas hat is disassembled to make a pattern for a new fashion product

### Commercial patterns

A **commercial pattern** includes an image, showing what the product should look like, and information about what you will need to make it. It also provides detailed instructions on how to use the pattern and make the product.

There are standard pattern markings that show how to use the pattern. Once you recognise these markings, you can attempt almost any pattern and understand how to make it easily.

## Using a tailor's dummy

Another way to make garment patterns from scratch is to use a **tailor's dummy**. Pattern drafting using a tailor's dummy is a skilled job and is something you can try after you have mastered using other patterns.

## Modelling

Making up and testing a product is called **modelling**. If the whole product is modelled to scale then it is called a **prototype** or **mock up**.

It is important to test a product to make sure that it functions as intended and to identify any changes that may need to be made.

## Using CAD in pattern drafting

The benefit of using computer-aided design (CAD) when making patterns, is that the operator can use pre-programmed patterns, and pattern grading techniques, to create a wide range of sizes that are accurate and easy to store on the computer.

The computer can also communicate this information directly to automated pattern cutters that cut the fabric pieces directly. This is known as computer-aided manufacture (CAM). Several pieces of fabric can be cut at the same time, and the computer can also work out the best way to lay out the pattern pieces on the fabric to save on waste.

| Pattern marking or symbol | Meaning |
|---|---|
| | Lengthen or shorten the pattern here |
| | The straight of the grain |
| | Lay on the folded edge of the fabric |
|  | Cutting line |
| | Position and size of zip opening |
| | Fitting or seam line |
| | These show where one piece should join onto another. They are called **balance marks**. |
| | Dart |
| | Centre of fold line |
| | Pleat |
| | Position and size of buttons |
| | Position and size of buttonhole |
| | Stitch in direction of arrow |

**B** Pattern markings

### Link

See **4.3 CAD** for more on CAD.
See **5.3 CAM** for more on CAM.

### Summary

- Patterns are used to allow a product to be made more than once.
- A pattern can be tested by creating a mock up or prototype – this is referred to as 'modelling'.
- Patterns can ensure accuracy and help as a guide to make up a garment or product.
- Computer-aided design can help to create patterns by using pre-programmed sizes and garment shapes.

### Activity

1  Disassemble a textiles product, and use it to make a pattern for a new product. Follow the instructions below.

  - Take an unwanted garment or textiles product. Unpick the parts of the product (you will need to use an unpicker for this).
  - Draw around each part to create a paper pattern.
  - Try making up the garment again, but using the pattern that you have created.
  - Once you have mastered this, try being creative and adapt the pattern to create your own design.

# 5.2 Production planning

## Objectives
- Know why it is important to have a production plan.
- Be able to list what things should be included in a production plan.

A **production plan** is a set of instructions for making a product. It should contain enough information so that someone who has never seen the product should be able to make it.

## Why do we need a production plan?

There are lots of reasons why you should plan out what you are going to do!

- It saves you money, as you only buy the materials that you need.
- It stops you accidentally missing out features on the product while you are making it.
- You will not waste time by starting to make something and then realising that you do not have the tools to finish it.
- You can identify any equipment that you need to practise on to improve your skills.
- You will know how long it takes to make the product.
- You can identify where you may get hurt so you can take action to avoid it.
- If the product is made again in the future, it will be the same.

## Key terms

**Production plan:** the instructions on how to manufacture a product.

**Flow chart:** a sequence of activities presented as a diagram.

## Deciding how to make the product

The first thing you need to do, is decide how you will make the product. This means that you need to know what material you can make the product from, and what processes you will use to make it.

For example, say you want a small zipped fabric purse (Figure **A**). It has fabric sides, piping and a zip. You will need to:

- measure and cut out your fabric
- sew up the seams
- insert the zip
- insert the piping.

Next, the tasks need to be put in the right order. Some tasks will need to be carried out before others can be done. For example, you might need to insert the zip first, as it would be difficult to get the purse on to the sewing machine once you have sewn the seams up. The final order can be shown as a **flow chart** (Figure **B**).

**A** Simple zipped purse with piped edging

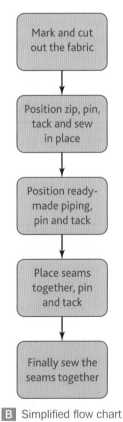

**B** Simplified flow chart for making the purse

Chapter 5 Preparing for making

# Writing the production plan

On its own, the flow chart does not give enough information to make the product. The other things that you need to know must now be put into the production plan.

Each of the tasks in the flow chart is normally listed as a separate step in the production plan. For each step, there should be enough detail that the person carrying it out should not need any more information.

In industry, if you have a product with lots of different parts, you would normally write separate plans for each part. You may also have a production plan for putting all the parts together to make the finished product.

## What should be included in the production plan
- The tasks you need to do
- What materials to use
- What tools to use
- Safety notes
- The time needed to do each task

### Activity

1 Making a cup of cocoa involves the following activities (not in order).

Pour hot milk into cup

Get a cup from the shelf

Put 2 spoonfuls of cocoa in cup

Stir

Heat milk in a pan

- Create a flow chart showing the tasks in the correct order.
- Create a production plan that could be used by someone who had never seen a cup of cocoa being made.

| Step: | Task | Time, minutes | Tools to use | Materials to use | Safety notes |
|---|---|---|---|---|---|
| 1 | Mark and cut out the fabric | 10 | Tailor's chalk, fabric, steel rule and dressmaking scissors | Printed cotton | When cutting out fabric keep the scissors on the table; do not cut in mid-air. Keep the free hand out of the path of the scissor blades. |
| 2 | Position zip, pin, tack and sew in place | 25 | Pins, needle, and sewing machine | Printed cotton, zip and tacking thread | Correct handling and use of pins and needle; use thimble to prevent pricking of finger. Correct handling and use of sewing machine; follow safety guidelines. |
| 3 | Position ready-made piping, pin and tack | 25 | Pins and a needle | Tacking thread and ready-made piping | Correct handling and use of pins and needle; use thimble to prevent pricking of finger. |
| 4 | Place seams together, pin and tack | 10 | Pins and a needle | Tacking thread | Correct handling and use of pins and needle; use thimble to prevent pricking of finger. |
| 5 | Finally sew the seams together | 15 | Sewing machine | Sewing thread | Correct handling and use of sewing machine; follow safety guidelines. Make sure that all pins have been removed before sewing on the machine. |

C Example of a production plan for making the purse

### Summary

- The production plan gives you instructions on how to make the product.
- It should include all the information needed to make the product, including the tasks to be carried out, the materials and tools to be used, and safety notes.

# 5.3 CAM and CIM

## Objectives

- Be able to explain what is meant by CAM and CIM.
- Be able to state the advantages of using CAM.

## Key terms

**Computer-aided manufacture:** using computers to operate machine tools.

**Computer-integrated manufacture:** using computers to control the entire production process, with no human input.

## What is CAM?

When using machine tools to make products, there are two ways in which they can be controlled: manual machines are controlled by skilled workers and CAM machines are controlled by computers.

**Computer-aided manufacture** (CAM) means using computers to control the machine tools. These machines are also called computer numerical control (CNC) machines, as the computer uses numbers to control what they do. There will probably be several CAM machines in your school, including CAM sewing machines.

## Why use CAM?

CAM has several advantages over manual machines.

- CAM machines can work faster and more accurately.
- They can do a job again and again, and the product will be the same every time.
- They do not need to take breaks – they can work continually, 24 hours a day, 7 days a week.
- They can produce shapes that are difficult to manufacture using manual machines.

There are two main disadvantages to using CAM machines.

- They are more expensive than manual machines. This means that they are normally only used when there are lots of garments to be made.
- It can take a long time to write the program to operate them.

## CAD CAM and CIM

If a product has been drawn using CAD, computer software can analyse the drawing and create the control program, (Figure A). This can be downloaded straight to the CAM machine to make the part. This linking of processes is referred to as CAD CAM.

**Computer-integrated manufacture** (CIM) is an advanced form of CAD CAM, where computers control the entire production process. CIM is a fully automated system, where individual processes exchange information with each other and initiate actions without any human input.

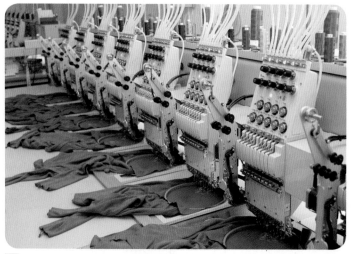

A Computers communicating with embroidery machines to embellish a design on to fabric

Chapter 5 Preparing for making

## Case study

### Texplan Manufacturing Ltd

Texplan Manufacturing Ltd offer design and manufacturing services for the textiles, wallcovering and paint industry. Their design studio is a good example of how CIM and CAM are used in the textiles industry.

They possess a large colour scanner that can scan artwork up to 1 metre by 2 metres in size. Detailed designs can be scanned into the system, capturing all the detail and colour of the original artwork. This scanned image is then transferred to the experienced CAD artist workstations, where the design is perfected.

Once the artist is happy with the design, and colours have been chosen, the computer communicates directly with an inkjet printer using CIM. The printer then prints the design on to fabrics.

Larger runs of printed fabric are produced on the screen-printing machines, which are designed to print larger quantities. These large printers are also linked up to the CAD system using CIM. A computerised colour kitchen mixes the required dyes, and then the fabric is printed.

- Why do you think Texplan choose to use CAD and CAM for these processes, rather than designing and manufacturing by hand?

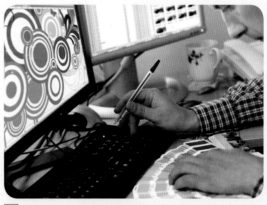

**B** Artist working on designs ready to communicate directly to the printer

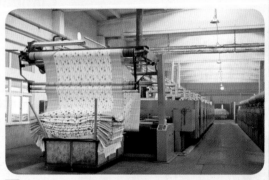

**C** Design being printed on to fabric from information received from the computer

### Activities

1. Using the facilities available in your school, use CAD to design a flag or logo for your school and then manufacture it on to fabric using a CAM machine.

2. Write an article that could be used in an interiors magazine, explaining how the use of CAM during the manufacture of interior products could benefit the customer. The article should have a maximum of 200 words.

3. Create a cartoon strip that shows the sequence of tasks to be carried out when using CIM to design and make a simple logo using a CAM machine. This should be suitable for explaining CIM to Year 6 pupils.

### Summary

- CAM is the use of computers to operate machine tools.
- CAM machines can be faster, more consistent and more reliable than manual machines. However, they need time to program and are more expensive.
- CIM is a fully automated form of CAD CAM.

# Chapter 6  Evaluation

## 6.1 Evaluation

Once you have finished making your product, you need to check that it meets all the needs you identified early in the design process.

### Functional testing

The first step in evaluating the product is to check that it satisfies the design brief. One way to do this is **functional testing**. This normally means trying it out. For example, if the design brief was to make a fabric shoe caddy that holds 10 pairs of shoes, you could check that 10 pairs of shoes fit into it.

### Comparing the product to the specification

Functional testing does not normally cover all of the needs that the product must satisfy. For example, it probably would not cover cost, aesthetic appeal, or constraints concerning which processes could be used to make it. To evaluate these needs you should test every need in the specification. This will probably mean that a number of different tests need to be carried out.

Where possible, any testing should be **objective**. This means that it should be based on facts and numbers, rather than opinions. The case study opposite shows an evaluation against the specification for a fabric baby/toddler book. This has a mixture of objective tests and opinions.

### Using the evaluation to improve the product

During the evaluation, you may identify some needs that have not been met. If this happens, you must explain why they have not been met. You should also identify what could be improved to allow them to be achieved.

Even if your final product meets all the needs, there may be some things that you are not happy about. For example, you may not like the quality of the finish, or that the shape of the design made it difficult to make. This is normal, as your skills and knowledge are improving as you are designing and making your product. You should note down any improvements that could be made. In industry, this is very important, as the next person to make the product can use your ideas to improve the product.

### Objectives

- Understand why it is important to compare the product to the specification.
- Be able to use evaluation to identify how the product could be improved.

### Link

See **1.5 Specification** for more on specifications.

**A** Functionally testing a fabric shoe caddy

### Key terms

**Functional testing:** testing in real use to check that the product does what it is meant to do.

**Objective:** based on facts rather than opinions.

Chapter 6 Evaluation

## Case study

### Educational toy for a child

This is an example of testing against a specification for a baby/toddler fabric book.

| Specification | How tested | Result of testing | Pass/fail |
|---|---|---|---|
| 1 The product should be a soft fabric book. | Visual check | The book is square. | Pass |
| 2 It should have removable characters that can be placed on to different pages in the book. | Functional testing by my two-year-old brother | He could move the animal characters around while looking through the book. | Pass |
| 3 It should be brightly coloured, with red, blue, yellow, green, purple and orange. | Visual check | It has parts of all the different colours. | Pass |
| 4 It should have a soft, smooth finish that can be easily cleaned. | Try washing by hand after it has been played with by brother. | Suitable for hand washing. | Pass |
| 5 It should be suitable for use by children aged 0 to 3 years. | Functional testing by my two-year-old brother | He liked it. | Pass |
| 6 The cost of the materials used to make it must be less than £10. | Added up the cost of the materials used | £6.50 | Pass |
| 7 It must be made of organic cotton from a sustainable source. | By asking the people that supplied the cotton | They said it was 100% organic cotton and had manufacturing labels to prove this. | Pass |
| 8 The book should fit into the hands of the children who use it. | Functional testing by my two-year-old brother | He could pick it up, turn the pages and hold it easily. | Pass |
| 9 It should have no sharp edges. | Silk test – pulling a piece of silk over the product and seeing if it snags | No snags. | Pass |
| 10 It should have no small parts that may be swallowed by a child. | Use choke tester from local toy shop to check size of removable animals | No parts fitted into the choke tester. | Pass |
| 11 It must be able to be made as a one-off product using hand tools. | By making it | Pass | Pass |
| 12 The fabric pages should be constructed using a sewing machine and printing methods. | By making it | Pass | Pass |

## Activities

1 Create a list of the tests that could be carried out during the evaluation of a bag. Using these tests, work out what the specification for the product was.

2 In the case study, identify which of the tests carried out were objective and which were based on opinions. For each test based on an opinion, identify either a way of testing objectively or suggest how the specification could be changed to allow objective testing of that need.

## Summary

- Functional testing should be carried out to make sure that the product works as intended.
- The product should be compared to the specification to check that it meets all of the identified needs.
- You should also identify how the product could be improved.

# Chapter 7  Materials and components

## 7.1 Fibres and fabrics

### Objectives
- Understand the origin of fibres and fabrics.
- Understand the different groups of fibres, and how fibres are made into fabrics.

### Key terms

**Fibres:** long, thin strands of material, which are twisted (spun) together to make yarn.

**Staple fibres:** short fibres mostly from natural sources.

**Filament fibres:** long fibres, mostly from synthetic sources.

**Durability:** how hard-wearing something is.

**Yarns:** fibres spun on to a roll ready to be made into fabric.

### Fibres

Take a close look at your clothing and you will see that it is made up of tiny strands of fibres. Did you know that some of those tiny fibres actually come from oil and coal?

### Groups of fibres

As you can see in the flow chart below, fibres can be grouped into two types: natural and man-made. Natural fibres come from plants or animals, and man-made fibres come from materials such as crude oil and wood pulp.

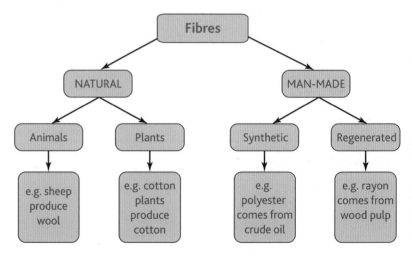

### Staple and filament fibres

Fibres can also be grouped according to their length.

1 **Staple fibres** are natural fibres in short lengths. Examples include cotton, wool, flax and hemp.
2 **Filament fibres** are mostly synthetic fibres (with the exception of silk) in long lengths. Examples include acrylic, nylon and polyester.

### Properties of fibres

Below are some different properties that are taken into consideration when choosing the right fibres to be made into different materials.

- Strength – how strong does the fabric need to be?
- **Durability** – does the fabric need to be hard-wearing?
- Elasticity – how 'stretchy' should the fabric be?
- Crease resistance – is it important that the fabric does not crease easily?
- Easy to clean – does the fabric need to be washed regularly?

Chapter 7 Materials and components

# From fibres to fabrics

There are four stages in the process that makes fibres into fabrics (see below). The fabrics are then used to make textiles products.

> ### Activity
> 1. Different fabrics are used for different purposes. Look at the labels on your school shirt and/or jumper. Can you identify which fibres your clothing is made from? Are they natural or man-made?

**A** Source of fibre (for example, sheep)

**B** Fibre spun into **yarns** and placed into rolls

**C** Yarns woven/knitted into fabrics

**D** Finish put into fabrics (for example, Teflon)

> ### Summary
> - Fibres can also be grouped as staple (short) and filament (long).
> - There are two groups of fibres: natural and man-made.
> - Fibres have a wide range of properties that need to be considered when choosing the right fabric for the right products.

# 7.2 Fibres and fabrics continued

## Objectives
- Understand the two main groups of fibres.
- Understand the types of fabrics within the fibre groups and what they are used for.

Fibres are grouped according to their origins: natural or man-made.

## Natural fibres
Natural fibres are made from parts of plants or animals. These types of fibres have been used to make fabrics for thousands of years.

### Plant fabrics
**Cotton** grows in hot climates, on bushes from seeds. When the seeds ripen they split open to reveal fluffy white cotton. The fabric is cool to wear and is long lasting, but creases easily. Products made from cotton include jeans, blouses, T-shirts, sheets and towels.

**Linen** is made from the inner bark of the flax plant. The plants have a straight stalk with blue flowers, and are grown mostly in Europe. Products made from linen include tea towels, tablecloths and summer clothing.

### Animal fabrics
**Silk** is made from the cocoon larvae of the silkworm, and was first developed in China. The fabric has a smooth, soft texture and is one of the strongest natural fibres. The fabric can be warm to wear and creases can drop out easily. However, it can be static and it needs to be dry cleaned. Products made from silk include evening wear, ties and scarves.

**Wool** is taken from the coats of sheep and other animals, such as goats, alpacas, camels and even rabbits! There are many different types of wool. It is used for warm clothing, suits, blankets and furniture upholstery. However, wool can shrink and it is not as durable as cotton and silk.

A Gloves made from wool

## Man-made fibres
Man-made fibres are made from chemicals taken from raw materials, which include wood pulp, coal and oil. They are generally more modern fabrics. Man-made fabrics are split into two groups: synthetic and regenerated.

### Synthetic fabrics
Synthetic fabrics are made from chemicals and oils.

**Nylon** is made by combining chemicals that are taken from coal, water, air, petroleum, natural gas and agricultural by-products. Nylon is lightweight, strong, durable and resistant to damage. It also takes dye easily, making nylon fabrics available in a wide range of colours. Products made from nylon include swimwear, wetsuits, umbrellas and waterproof bags.

## Activities
1. Make a list of the clothes you are wearing and other textiles products around you.
   - Note what fabric they are made from.
   - Note what the origin of this fabric is.
2. Working in pairs or groups, discuss whether natural or man-made fabrics are more suitable for making the following products:
   - an evening dress
   - a duvet cover
   - a swimming costume.

   Give reasons for your answers.

Chapter 7 Materials and components

**Polyester** comes fom crude oil. When made into fabric, it tends to feel slippery and silky. Some polyester is blended with other fabrics to provide more stretch, or to reduce skin irritation. The fabric can be easily dyed and is not damaged by mildew. Products made from polyester include shirts, jackets and furnishings.

## Regenerated fabrics

Regenerated fabrics are made by processing cellulose, which comes from wood pulp and cotton.

**Rayon** is the main type of regenerated fabric, and there are many different types of rayon. The following products can be made from rayon: blouses, dresses, jackets, lingerie, linings, scarves, suits, neckties, hats and socks.

**Acetate** is a form of rayon. It was discovered in Switzerland in the early 20th century. It is mainly used in satin and is also blended with silk, cotton and nylon. Mixing fibres in this way can create fabrics that have some of the properties of both fibres, and are suitable for different purposes.

**B** Tights made of nylon

### Key terms

**Natural fibres:** fibres made from parts of plants or animals.

**Man-made fibres:** fibres made from wood pulp, oil or coal.

### Case study

#### Silkworms

The silkworm is actually a caterpillar, not a worm.

For over 4,000 years silkworms have been used in silk production. The process was first discovered in China around 2600 BC and they kept it a secret, supplying the fabric to Europe and the rest of the world.

A silkworm moth is a yellowish-white colour, has a thick, hairy body, and a 4 cm wingspan. They are farmed by humans in order to produce silk.

The larvae (which come from the eggs) hatch in about 10 days. They are fed on the leaves of the white mulberry plant. This plant food helps produce the finest quality silk. After about six weeks of continuous eating, the larvae climb to the top of a branch and spin their cocoon. They are then killed by heat to retrieve the silk thread.

It takes 50,000 cocoons to make just one kilogram of raw silk, which is why silk is such an expensive, luxury fabric.

### Activities

3  Draw a flow chart showing the process of a silkworm being made into silk. Start with the adult moth laying the eggs.

4  List examples of textiles products that may be made from silk.

### Summary

- There are two groups of fibres: natural and man-made.
- Man-made fibres are mostly made from chemicals, and natural fibres are made from plants and animals.
- Both natural and man-made fibres can be mixed to create other types of fabrics suitable for different purposes.

**C** Silkworm cocoons

**D** Silk is made into luxury textiles products, such as scarves

# 7.3 Fabric construction

## Objectives

- Understand the way in which fibres are made into yarns.
- Understand some of the different types of spinning.

### Link

See **7.4 Fabric construction continued** for more about warp and weft.

## Spinning

Fibres are made into yarn by the process called **spinning**. This is when the fibres are twisted together to add strength and produce yarn, which is then made into fabric.

The earliest type of spinning was using animal hair or plant fibre, which was rolled down the thigh with the hand. Later, the fibre was fixed to a stone, which was turned around until the yarn was twisted tightly enough.

The spindle was the next method of making yarn. This was a straight stick, 8–12 inches long, which was used to twist fibres into yarn.

More modern powered spinning was done using water or steam. Spinning machines are now powered by electricity.

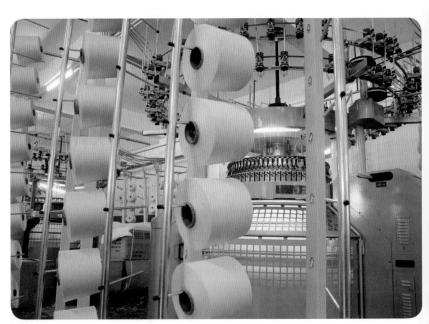

**A** Modern spinning machines are powered by electricity

## Twisting

When two or more fibres are spun together, it is called a twist. There are two types of twist: the **S twist** and the **Z twist** (Figures **B** and **C**).

### Key terms

**Spinning:** the process of twisting fibres into yarns.

**S twist:** the clockwise twist of fibres.

**Z twist:** the anticlockwise twist of fibres.

**Plies:** the number of fibres twisted together to create a yarn.

**Blended:** more than one type of fibre twisted together for a mixed effect.

**Worsted:** where yarn is spun tightly, like a rope.

## Chapter 7 Materials and components

B S twist: clockwise twist of fibres to the left

C Z twist: anticlockwise twist of fibres to the right

## Plies

**Plies** is the number of fibres twisted together to create a yarn. It can be anything from two, three, or more, twisted around each other in either direction. Different fibres can be **blended** (twisted) together to create a mixed yarn for different effects of colour and texture.

# Types of spinning

**Worsted** spinning yarns are where the yarn is spun tightly, like a rope. Woollen spinning yarns are much looser, with more air running through them. This gives a different texture to the yarn, and to fabrics made from it.

### Case study

#### The Industrial Revolution and the spinning jenny

The Industrial Revolution was a period in the 18th and 19th centuries. During the Industrial Revolution, a lot of change took place in industry in Britain, including in fabric manufacturing.

The spinning jenny was invented in Lancashire in 1764 by James Hargreaves. The machine helped reduce the hard work it took to make yarn. It meant that one worker could work up to eight spools of yarn instead of one. Later models could spin up to 120 yarns at once.

The yarn that the machine produced was coarse and not very strong. This made it suitable for yarns going across the fabric (called weft), but not for the warp, which must be stretched on the loom.

As Hargreaves did not get a patent for the spinning jenny until 1770, other people copied his idea. The spinning jenny was later replaced by the spinning mule, which combined the spinning jenny with the introduction of water power, to give more control when spinning.

These developments had a direct influence on the way textiles are manufactured in the present day.

### Activities

1. Cut a sample of different thicknesses of cotton or wool yarns. Now take them apart and discover whether they are S or Z twists, and how many plies they have. Record your findings.

2. Use some different coloured fibres (from thread or wool) and twist your own samples of yarns, using both directions of spinning.

### Summary

- There are two ways of twisting fibres to make yarns: clockwise and anticlockwise.
- The number of fibres used are called plies.
- Fibres can be spun either by hand or by machine.

# 7.4 Fabric construction continued

## Objectives

- Understand the different ways of creating fabric.
- Understand some of the different types of weave.

## Yarn to fabric

The clothing you wear is made from fabric, which is usually made by **knitting** or **weaving** yarns.

### Knitting

Knitting is made from a group of loops that are pulled through each other using needles. This method can be done by hand or by machine. By using different yarns and needles you can make different types of clothing, which can have varying textures, colours and weight.

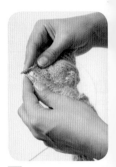

A Knitting by hand

### Weaving

Weaving is also done using yarns. There are two sets of yarns, called warp and weft. The warp yarns, which are stronger, are inserted into the **loom** lengthways, and the weft yarns are woven under and over them in the opposite direction. Weaving can be done by hand, but machine-operated looms are far more common in modern manufacturing.

There are a lot of different types of weave. Some of the most common types are shown in the table below, with examples of fabrics they are used for.

B Weaving on a loom

| Type of weave | Description | Types of fabric the weave is used for |
|---|---|---|
| Plain weave | Each yarn passes over and under each other. | Cotton, polyester |
| Satin weave | A single warp yarn passes over several weft yarns, or vice versa. | Furnishing fabrics |
| Twill weave | A weft yarn goes over and under several warp yarns, creating diagonal ridges across the fabric. | Denim |
| Pile weave | This creates a raised texture on the surface of the cloth. Wires or metal rods create the raised loops. These are removed after the fabric is made. | Velvet, corduroy |

Chapter 7 Materials and components

# Non-woven fabrics

There are also fabrics that are not knitted or woven. These are cheaper to make than knitted or woven fabrics. Below are two of the methods of making non-woven fabrics.

## Bonding

A bonded fabric is a non-woven fabric where the fibres are held together by a **bonding** material. This may be an adhesive (glue) or a bonding fibre with a low melting point.

C Bonded fabrics can be used for disposable products such as medical masks

## Felting

**Felting** is a method where fibres are pressed together using moisture, heat and pressure. The fibres are mixed together, and washed and pressed a number of times, to create a material that does not have a weft and a warp.

Felt used to be made just from wool, but today it is more often made from recycled or synthetic yarns.

D Felting wool used to make warm socks

E A mobile-phone case made from felt

### Key terms

**Knitting:** a method of making fabric where a group of loops are pulled through each other using needles.

**Weaving:** a method of making fabric where two yarns, warp and weft, pass over and under one another in opposite directions.

**Loom:** a machine for weaving yarn into fabric.

**Bonding:** a method of making fabrics where the fibres are held together by an adhesive material.

**Felting:** a method of making fabrics where moisture, heat and pressure are used to press fibres together.

### Summary

- Knitting and weaving are two ways of creating a fabric.
- Both these methods of creating fabric can be either done by hand or machine.
- There are also non-woven fabrics that are cheaper to make than knitted or woven fabrics.

### Activities

1 Look closely at the clothing you are wearing and see if you can identify the type of weave used.

2 Design a weaving style of your own using different yarns, fabrics and colours to create interesting effects.

## 7.5 Finishing fabrics

### Objectives

- Understand why we apply a finish to fabrics.
- Understand the types of finish that may be applied to different fabrics, and their purposes.

### Key terms

**Calendering:** pressing fabric between rollers to make it smoother.

**Mercerising:** putting fabrics into chemical baths to make them stronger.

### Finishes

Look at a piece of fabric. What sort of texture does it have? Smooth, shiny or rough?

A finish is something that is applied to the fabric to improve its quality. It may do some of the following things:

- make the fabric resistant to water, fire, creasing or static
- change the look or texture of the fabric
- make the fabric stain-resistant.

### Mechanical finishes

| Type of finish | Process | Fabrics treated | Purpose |
|---|---|---|---|
| Brushing | The fabric goes through a wire brush machine to 'fluff' the fabric up. | Cotton, wool and polyester | These finishes are all designed to alter the look and feel of the fabric. |
| Calendering | The fabric goes in between heated rollers to 'press' the fabric to give a smooth finish. | Cotton and wool | |
| Heat setting | For 'pressing' shapes or pleats into the fabric. | Polyester and nylon | |

A Pleating created by using the heat setting finish

B Firefighters' uniforms have a chemical finish applied to make them flameproof

44

## Chemical finishes

| Type of finish | Process | Fabrics treated | Purpose |
|---|---|---|---|
| Bleaching | Bleach is added to the fabric to remove the natural colour. | Cotton and synthetics | This allows fabrics to have a new colour added. |
| Mercerising | The fabric is soaked in chemical baths, which makes the fabric swell and adds strength to it. | Cotton, hemp | The stronger fabrics produced by mercerising might be used for products which need to be long-lasting, such as shirts or socks. |
| Adding resin | Adding a chemical called a resin to make the fabric less able to crease. | Cotton, silk | Crease-resistant fabrics are often used for shirts, so that they do not need ironing. |
| Adding flameproof chemicals | Adding a chemical to make the fabric more resistant to fire or flames. | Cotton, linen and rayon | This can be very useful for firefighters' uniforms, for example. |

### Activities

1. Find samples of fabrics that have been finished using some of the effects you have learned about. Label them accordingly.
2. Try a dry version of stonewashing by using pumice stones and a sample of denim. Rub the pumice stone against the denim and see how it rubs the colour away, creating a sample of the stonewashing effect.
3. Experiment to design your own finish for denim or another fabric, and try it out on a sample. What is its effect?

### Case study

#### Stonewashing denim

Denim is a popular fabric for clothing. One finish for denim is stonewashing.

Faded patches are created by the use of pumice stones being washed with the fabric – the denim is literally washed with stones. This faded look can also be acheived by the use of chemicals called enzymes.

Stonewashing also makes denim softer and more flexible, as it can otherwise be a very rigid fabric. This makes it more comfortable to wear.

What other finishes could you use on denim? What are their effects?

### Summary

- There are two main types of finishes: mechanical and chemical.
- Finishes improve the quality of the fabric, so it is more suitable for its use.
- They can also be used to change the appearance of a fabric.

# 7.6 Fabric choice and characteristics

## Objectives

- Understand how to decide on the right fabric for the right purpose.
- Understand the properties of different fabrics.

### @ Link

See **1.1 Reasons for product development** for more on products and needs.

### Key terms

**Absorbency:** how well the fabric soaks up liquid.

**Insulation:** how warm the fabric is.

## Choosing fabrics

Fabrics are chosen for a purpose. To choose the right fabric for the right purpose, designers need to think about the following questions.

- Does it need to be natural or synthetic?
- Does it need to be hard-wearing?
- Should it be warm or cold to wear?
- Should it offer protection from rain or windy weather?
- Should it be flameproof?

It is important to match up properties to what is needed for that product, as in the following examples.

- Children's woolly jumpers need to be warm, soft, resistant to dirt and easy to clean.
- Football socks need to be strong, flexible, stretchy and resistant to staining.
- Towels need to be, soft, absorbent and easy to clean.

## Properties of fabrics

The table below shows some common fabrics and their properties. It is a helpful way to choose fabrics that are suitable for their purpose.

|  | NATURAL FABRICS | | | | MAN-MADE FABRICS | | | |
| --- | --- | --- | --- | --- | --- | --- | --- | --- |
|  | Wool | Silk | Linen | Cotton | Acrylic | Nylon | Polyester | Viscose |
| Absorbency | | | | | | | | |
| Elasticity (stretchiness) | | | | | | | | |
| Resistance to flames | | | | | | | | |
| Insulation | | | | | | | | |
| Resistance to damage from sunlight | | | | | | | | |
| Level of static electricity | | | | | | | | |

**Key:** Very good / Good / Average / Poor

Chapter 7 Materials and components

## Case study

### Properties and characteristics of a football kit

Here is an example of the properties and characteristics of fabrics that need to be considered when designing a football kit.

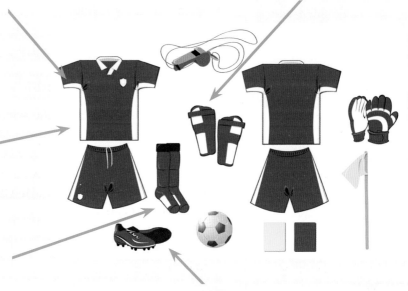

**Colours**
The colours are designed to show the team's **identity** on the pitch and allow the spectators and players to recognise them.
The colours need to be **coordinated** in all the items of the kit.

**Shin pads**
These are made of rubber or plastic, mainly for **protection** from the impact of being kicked or hit by the ball.

**Football shirt**
It is important that the material used is **light**, does not trap body heat, and is **tough** and **durable**. Football shirts used to be made from **cotton**. Now they are often made from **polyester**, **nylon**, or a **polyester-nylon mix**.

**Football socks**
Socks need to fit close to the skin, be **elastic** and **allow the skin to breathe** when the player sweats. They can be made of a **modern blend of materials** to meet all of these different needs.

**Football boots**
Football boots are usually made of **leather** or **man-made materials**.
They need to protect the players' feet from **wet conditions**. The boots need to allow **flexibility** for the feet to move when the players are running.

## Activities

1. **a** Choose an item of clothing and explain what its purpose is.
   **b** Use the table opposite to identify the properties of the fabric it is made from.
   **c** Now explain why the designer chose this fabric.

2. Choose some different fabrics and test for different properties, such as how stretchy they are. Create a table similar to the one opposite and rate your findings.

3. Choose a uniform from the list below and list the properties essential for each item of clothing.
   - Firefighter
   - Racing driver
   - A sportsperson of your choice (not the footballer!)

## Summary

- Fabrics are chosen for a specific purpose.
- The properties required have to be considered before designing an item of clothing.

47

# 7.1 Labelling

## Objectives

- Understand what labelling is required on textile products by law.
- Be able to identify some labelling symbols and what they mean.

## Key terms

**Care label:** this label has information that you are advised to follow to keep the product in the best condition possible.

**Quality label:** this label is given to a product that has met certain standards that test for quality of the product or how it was made.

**Safety label:** this label is given to a product that has passed safety testing standards.

## Activities

1. Do some research to find out more about the Lion Mark and explain what it means to the customer.

2. Find a product with a BS number on it. Try to find out what the number means. Does it tell you what it has been tested for?

If 80 per cent or more of a product is made from textile materials, then it is required, by law, to be labelled with certain information that the customer may need to know. This may include:

- how to wash and care for a product
- how safe it is, especially for young children
- how well it has been made
- where it has come from
- what it is made from
- how environmentally friendly it is.

## Care labelling and symbols

The table opposite illustrates the symbols that can be found on a **care label**. Each symbol indicates a specific instruction that you are advised to follow to keep the product in the best condition possible.

## Quality and safety labelling

We all want quality products, and we would like to also think that they are safe. A **quality label** is given to a product that has met certain standards that test for quality of the product or its manufacturing process (how it is made). A **safety label** is given to a product that has passed specific safety testing standards.

### European Safety Standard symbol

This symbol is also known as the CE mark. It tells the customer that the product's quality and manufacturing process have been tested. If the product failed to meet the required tests or standards it would not be allowed to display the CE mark.

A The CE mark

### The Lion Mark

Children's toys are tested for their safety by the British Toy and Hobby Association. If the association has agreed that a toy is safe then they will award the toy the Lion Mark. The Lion Mark identifies that it has met a particular British standard regarding safety for children's toys.

B The Lion Mark

### The British Standards Institute

The British Standards Institute (BSI) has a set of British tests and standards that tell the customer that products have met certain standards for

C The BSI Kitemark

safety and quality. These can be recognised by 'BS' followed by a number or the BSI Kitemark symbol.

All of these quality and safety marks are there to show the customer that the product they are buying is safe and of good quality.

**D** Care labels and what they mean

| Symbol | Meaning |
|---|---|
| | The wash tub indicates washing either by hand or by machine, depending on what is inside the tub image. If it has a big cross through it, then it is not washable. |
| 40 | A wash tub without a line or bar means that it can be machine washed at the temperature indicated. |
| 40 | A wash tub with a single line or bar tells you that it should be washed on a medium setting using the temperature indicated. |
| 40 | A wash tub with double lines or bars means that it should be washed on a minimum setting (often a wool setting) at the temperature indicated. |
| | A hand in the tub means wash by hand. |
| | This is the symbol for chlorine bleaching. It means that you can use any type of bleach on the product. |
| | If you use bleach in the wash, this symbol means only oxygen bleach or non-chlorine bleach is allowed. |
| | This simply means do not bleach. |
| | This is the symbol to tell you how to iron the product. |
| | This is the symbol for a hot iron. |
| | This is the symbol for a warm iron. |
| | This is the symbol for a cool iron. |
| | Indicates dry cleaning instructions. |
| F P W | The circle containing a P, F or W means that it must be professionally dry cleaned. The letters in the circle tell the dry cleaner what chemicals they should use to clean the product. |
| | This indicates that the product can be tumble-dried. |
| | This indicates that the product can be tumble-dried on a high heat setting. |
| | This indicates that the product can be tumble-dried, but only on a low heat setting. |
| | This simply means that the product should not be tumble-dried. |
| | A cross through any of the symbols means 'Do not … !' |

## Activities

3 Look at a care label on a garment you are wearing and draw out the symbols, noting down what they mean. If you get stuck you can refer to the table provided.

4 See if you can find an environmentally friendly label, otherwise known as an eco-label. Write down what it means to the customer. Include the symbol if there is one to go with it.

## @ Link

Here are some websites you may find useful:

www.care-labelling.co.uk
www.bsigroup.co.uk
www.btha.co.uk

## Summary

- Labels on textiles are used to help the customer know what a product is made of, where it is from, what size it is, etc.
- Care labels help you to understand the best way to clean and look after a product.
- Safety labels act as a warning for potential hazards.
- Quality labels offer some reassurance that a product meets a required standard and quality.

# 7.8 Textiles components

## Objectives
- Know the names of a range of textiles components.
- Be able to identify and evaluate their use.

## Key terms
**Components:** things needed to make a product, apart from the fabric.

**Functional:** something with a purpose or job to do.

**Decorative:** making something look better.

 **Link**

See **7.9 Smart and modern materials** for more on smart dyes.

**Components** are all the things needed to make a product, apart from the fabric.

They can be **functional**, which means they have a purpose: for example, using buttons to close a shirt. They can also be **decorative**, such as a ribbon decoration. When you choose components think about the following questions.

- What components best suit the person using the product?
- What is the purpose of the component?
- Where will the component be placed on the product?
- Will the component be suitable for the type and weight of fabric being used?
- What colours and styles of component are available?
- Are there any safety considerations, especially if the product is for a child?

## Types of components

### Threads
Different types of thread have different uses: such as sewing machine thread, embroidery thread, metallic thread, buttonhole thread. It is important to choose the correct type to get the finished look you want.

### Fastenings
These include zips, buttons, buckles, poppers, hook and eyes, Velcro, toggles and eyelets. These all do the job of holding something closed.

A Beads, sequins, buttons and other trimmings have been used on this Christmas tree decoration to add texture and colour to the design

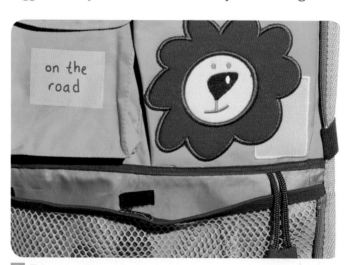

B This toy wallhanging uses several components. Binding has been used to neaten the edge of the pocket. The pocket also has a Velcro fastening. Cord has been used to make the lion's legs, and interfacing is hidden away under the lion appliqué motif to make it stronger.

## Dyes

There are a wide range of dyes used on textiles fabrics to add colour and decoration. Specialist dyes are also available, such as 'smart' dyes that glow in the dark or change colour with heat or in sunlight.

## Interfacing and wadding

Interfacing is used underneath fabrics to add strength: for example, under embroidery, under buttons and buttonholes, and inside collars and cuffs. There are a variety of different types including Bondaweb, which is sticky on both sides, and can be used to join two layers of fabric together, or to attach appliqué motifs before sewing. Wadding is used in quilting between layers of fabric. When the layers are stitched it produces a padded effect.

## Shoulder pads and boning

These are used to add shape to a product. Shoulder pads are used in jackets and tops to give a padded effect around the shoulders. Boning is used on dresses and corsets to shape the product to the body.

## Binding and elastic

Binding is a narrow strip of fabric that can be used to neaten or decorate an edge. Elastic is used to allow something to change its shape and size when it is used.

## Trimmings

This includes ribbons, braids, lace, beads and sequins. These are mainly used to add decoration to the surface of a product.

## Pre-manufactured embroidered motifs

Embroidered fabric badges can be bought and sewn on to a product to add decoration or to show membership of a team or group.

### Case study

#### E-Textiles

The latest development in components is the use of electronic modules in textiles products: for example, LED lights, solar panels and sound modules. These can be decorative or can add extra functions to a product, such as being seen in the dark. When designing these products, a designer has to consider how the device will be powered and how the product might be washed. Textiles products of the future might have mobile phones, satellite navigation systems, MP3 players, or other electronic devices built into them, and they will have 'soft switches' to turn them on and off.

- What are the advantages and disadvantages of textiles products that have electronic sound and light modules in them?

### Activities

1. Look at three different textiles products. Draw a table to show the types of components that have been used on each product. Include a column on your table where you can suggest an alternative component you could use to the one that has been chosen.

2. Design a product of your own that includes a range of components. Label the components that have been used.

C  LED lights that are light sensitive to movement have been used in this motif on a child's pyjamas. The lights are turned on by a flexible switch (soft switch run by a tiny battery that sits under the surface of the fabric.

### Summary

- Components are the things needed to make a product – apart from the fabric – such as zips, buttons, thread, dye and interfacing.

- When choosing components, consider who the user is, what the product is, and where the component will be used.

# 7.9 Smart and modern materials

## Objectives
- Understand smart and modern textiles and some of their uses.

## Key terms

**Smart fabrics:** textiles products that respond to their environment without human interaction.

**Modern** or **interactive fabrics:** fabrics that need a power source to activate their electronic features.

**Biomimetics:** imitating, copying or learning from nature.

When you think of textiles products, you are likely to think of fashion or decorative interior products, but this is a very limited view of textiles technology. We live in exciting times, where technology is constantly changing to develop new and innovative products. Here you will discover that textiles are at the forefront of some exciting developments in technology.

## What is a smart fabric?

A **smart fabric** is able to react automatically to its surroundings without someone interacting with it in any way. These fabrics can respond to various conditions including heat, moisture and light. You may have come across gloves that have glow-in-the-dark printed designs, which are great fun, but can also offer a safety feature for cyclists who need to be visible in the dark.

## What are modern fabrics?

**Modern** or **interactive fabrics** are like smart fabrics, but may need human interaction or a power source. There are a wide variety of interactive fabrics that incorporate electronics. Weaving with metallic fibres into fabrics, or printing or coating fabrics with metallic dyes or veneers, allows them to conduct electricity. These specialist fabrics can be used for heated car seats, heated motorbike clothing, fabric computer keyboards, and for wearable technology such as clothes with built-in cameras and mobile phone technology.

## Why use smart and modern fabrics?

Smart fabrics can be fun, but they serve many functional purposes too. Here are just a few examples of the things they can be used for.

- Disposable fabrics that change colour when wet are used for babies' nappies.
- Fabrics dyed using photochromic dyes respond to light by changing colour. These are used for military clothing to help with camouflage when soldiers move from night to day.
- Thermochromic dyes can react to heat and change colour. This is very useful when applied to beachwear – the fabric warns the wearer if they have too much exposure to sunlight.
- Fabrics that offer antibacterial qualities are currently being used in the medical profession to help heal wounds and prevent infection.

A The application of a warm hand to the thermochromic dyes in this garment has caused its colour to change

Chapter 7 Materials and components

- Fibre optic sensors have been inserted into military garments to detect harmful chemicals.
- There are a number of products, including the 'life shirt', that can monitor blood pressure and heart rate. It sends messages to the wearer's mobile phone on their current state of health.

## Case study

### The Speedo Fastskin

The smart Speedo Fastskin swimsuits were developed using biomimetics. **Biomimetics** means imitating, copying, or learning from nature. The suits are designed to mimic the skin of a shark – nature's fastest aquatic creature.

The swimsuit is worn by Olympic swimmers. During the Sydney Olympics in 2000, 28 of the 33 Olympic gold medals were won by those who wore Speedo Fastskin swimsuits. These amazing results made it the most successful swimsuit in the history of the Olympic Games.

- What other uses can you think of for Speedo Fastskin?
- Can you think of something in nature that you could copy and make good use of?

B Olympic Speedo Fastskin swimsuit

## Activities

1. Write a list of as many smart and modern materials that you can think of. You could even do some research to discover some that are not listed here.
2. Design an item of clothing that uses smart or modern materials using the following process.
   - Choose a user. This could be a person of a particular age group, a disabled person, or someone who participates in a particular activity.
   - List what the user's difficulties or needs are.
   - Write down the smart or modern materials you think may help to solve or improve each of these points. You can use your own list of smart and modern materials to help you.
   - Sketch three ideas. Each one must include at least one smart or modern material.
   - Label your design to explain how its features work and how it could help the user.

## Summary

- Smart and modern fabrics offer features that conventional fabrics do not have.
- Smart and modern fabrics can be used to enhance and improve fabric function and purpose.
- These new fabrics make the possibilities for design very exciting.

# Chapter 8 Making

## Textiles equipment

### Objectives

- Be able to identify and understand the basic equipment used in textiles.
- Understand how to use an iron safely.

There are many pieces of **textiles equipment**, including complex machines and tools. Before you advance to using such equipment, it is important to familiarise yourself with the simple tools and equipment you will use when working with textiles. Textiles equipment is used to help plan, mark out, join and decorate fabrics when making textiles products or pieces of artwork.

### Basic textiles equipment

It is useful to have your own textiles equipment kit so that you can use it both at home and at school. The most widely used pieces of textiles equipment include:

- pins in a suitable container
- pin cushion (one that goes on the wrist is very handy)
- sewing needles (various sizes, including an embroidery needle)
- fabric scissors
- small general-purpose scissors
- unpicker
- tailor's chalk
- tape measure
- thimble
- sewing bag or box to put equipment in
- safety pins
- needle threader
- different coloured threads
- spare buttons and ribbon (it can be handy to keep these in your sewing kit).

### Link

See **7.8 Textile components** for more on interfacing.

See **8.8. Appliqué** for more on appliqué.

### Activities

1. Using the list of basic textiles equipment, find or draw a picture of each piece of equipment so that you know what it looks like. Next to each of the pictures, write down what that piece of equipment is used for.

2. Put together your own textiles kit so that you can use it at home and at school.

3. Once you have some basic sewing skills, look for a simple sewing kit/bag pattern on the internet, and make your own bag for your textiles kit.

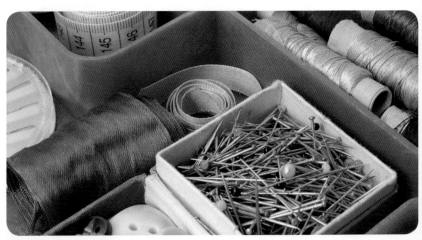

A  Some basic textiles equipment

Chapter 8 Making

# Using an iron

Most fabrics are prone to creasing. To work with fabrics you generally need them to be flat and as crease-free as possible. The best way to achieve this is to use an **iron**. You probably know that **ironing** helps to remove creases from fabrics. You may even have already used an iron, but if you have not then you will probably get the opportunity to use one in your Textiles Technology lessons.

You can use an iron for **pressing** too. Pressing is when you want a crease to stay in a fabric, on a collar, for example, or a pleat down the front of a pair of trousers.

In industry, ironing is done by hand using large steam irons. Some garments are placed in a specialist steam room that helps the creases to fall out, and large presses are used for pressing in creases.

## Important things to remember when using an iron

- Always use the iron on an ironing board.
- Never touch the sole plate. It is hot and will burn you.
- You can add water to some irons to make steam, which helps to get the creases out. Always unplug the iron when you are adding water.
- Check that the iron is on the right heat setting for the fabric. If it is too cool, it will not get the creases out, and if it is too hot, it could burn or melt the fabric.
- Never talk while you are ironing – always concentrate.
- Do not leave the sole plate still and down on the fabric for more than a couple of seconds – always keep the iron moving.
- Always turn the iron off when you are not using it.

## Other uses for the iron

An iron can also be used to help dry out fabric. This can be quicker than letting it dry naturally, but you must be careful not to scald yourself on the steam it creates.

Another use for the iron is to apply the interfacing material Bondaweb, which can be used in fabric appliqué. Bondaweb, which is used to join fabrics together, requires heat and a little moisture to activate the adhesive within it.

### Key terms

**Textiles equipment:** different tools used to help plan, mark out, join and decorate fabrics when making textiles products or pieces of artwork.

**Iron:** a tool that is used to get creases out of fabrics.

**Ironing:** the process of getting creases out of fabrics using an iron.

**Pressing:** applying heat and pressure to create creases or pleats.

B Person using an iron safely

### Summary

- You will need to use various different pieces of textiles equipment to make textiles products.
- Identifying the right piece of equipment for the right job is important.
- You must be shown how to use textiles equipment safely before you have a go yourself.

### Activities

4 After a demonstration, have a go at using an iron on different types of fabric to see which is easiest to iron.

5 Draw the iron that is used at home or in your classroom, and label all the features on the iron.

6 Design a health and safety poster for using the iron, which go on the wall in your classroom.

# Using a sewing machine

## Objectives

- Understand the features and functions of a sewing machine.
- Understand the differences between a basic sewing machine and CAD/CAM sewing machines.
- Understand and begin using a sewing machine.

A sewing machine is a general piece of equipment that most textiles classrooms will have. There are different makes and models of sewing machines, so it is a good idea to familiarise yourself with the types of sewing machine that are used in your classroom.

It is a common error to think that a sewing machine is difficult to use and easy to break. In fact it is very difficult to break one simply by using it. However, you do need to respect that the sewing machine will only work well if you use it correctly.

The first thing you need to understand is what all its functions are. There are many switches, levers and knobs that you need to understand, but once you know what they are, you will find that they are very similar on most basic machines.

## Basic sewing machines

The most common sewing machines are used to join fabrics quickly and professionally. Sewing by hand is time consuming and the quality can be inconsistent, so a sewing machine can help to improve the quality of your making.

You can use a sewing machine for adding decoration, but a basic machine will only have a limited number of preprogrammed decorative embroidery stitches, and possibly a buttonhole function.

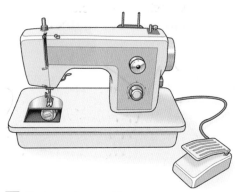

**A** Basic sewing machine

### Activities

1. After a demonstration of the sewing machines in your classroom:
   - make labels showing all the functions and features that your sewing machine has
   - see how many of the features you can remember by sticking your labels on to the correct parts of the sewing machine.

2. Try the following once you are confident that you know what the functions and features of your sewing machine are.
   - Take a piece of lined paper and try machining along the lines. You do not need to thread the machine first, just get used to the feel of the machine.
   - Now thread the machine up. It can be tricky at first, but practice makes perfect!
   - Now take a new piece of lined paper, and try sewing along the lines with the machine threaded. Machine slowly along the lines using both hands to guide the paper gently, but do not pull on it.
   - As you get more confident, you can have a go at drawing wavy lines on a piece of plain paper and sewing along these lines too.

### Remember

Practise on your sewing machine to help you gain confidence and skill. It is difficult to break a sewing machine just by using it, so have a go!

Chapter 8 Making

The sewing machine, like any electrical equipment with sharp and moving parts, needs the correct health and safety training. You should only use a machine once you have been shown how to use it correctly and safely.

## CAD CAM sewing and embroidery machines

A basic sewing machine will offer most of the skills you need to make good quality textiles products, but if you want to create your own embroidery or designs then you will need a CAD CAM sewing machine. **CAD** stands for computer-aided design. **CAM** stands for computer-aided manufacture.

Using CAD CAM, you can design a product on a computer, and then another computer will make it for you. For example, you can design an embroidered logo on the computer using CAD software, and then you can send the design to a CAM embroidery sewing machine, which will accurately sew the design.

There are many different types of CAD CAM sewing and embroidery machines. If you have CAD CAM sewing machines in your school, it is worth learning how to use these machines safely and correctly.

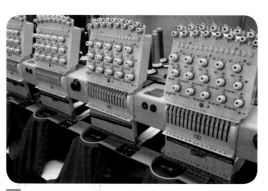

B CAD CAM sewing and embroidery

### Key terms

**CAD:** computer-aided design – designs can be drawn using computer software.

**CAM:** computer-aided manufacture – computers can communicate with machinery that can translate a CAD design into products.

### Link

You might find these websites useful.

www.actifwear.co.uk
www.startsewing.co.uk

### Link

See **4.3 CAD** and **5.6 CAM** for more on CAD and CAM.

### Case study

#### Actifwear

Actifwear are a company that have made a business from using CAD CAM embroidery sewing machines.

Actifwear provide all types of clothing to lots of different customers, including businesses, clubs, schools and nurseries. They have their own printing and embroidery equipment, which means that they can embellish (decorate) clothing with any type of design or effect.

Many of Actifwear's customers want their own logo or motif adding to a garment. This is quite easy to do in large numbers using their specialist industrial CAD CAM embroidery sewing machines.

- Why would it be difficult to do this without using CAD CAM?

### Summary

- Sewing machines can speed up sewing and give a higher quality finish than hand sewing.
- CAD CAM sewing machines can be used to add decorative features and embroidered designs.
- All sewing machines have sharp, moving parts that can be dangerous. You should have the correct training before operating a sewing machine.

# 8.3 Seams and seam finishes

A **seam** is a way of joining two pieces of fabric together. It is known as a **construction technique**, as its main purpose is to do a job rather than just to be decorative. When you choose seams think about the following points.

- Who will use the product?
- What will it be used for?
- Where will the seam be on the product?
- What fabrics are being used?
- How do you want the seam to behave: for example, do you want it to be strong, do you want it to be invisible?
- What do you want the seam to look like on the right and wrong side when it is finished?
- What equipment and machinery is available?

All seams have a **seam allowance**. This is the distance away from the edge of the fabric that you sew the seam. On a pattern you buy from the shops this is usually 1.5 cm.

## Types of seam

### Plain seam

This is the most common type of seam that can be used on most products. It is quick and easy to do. It is made by sewing two pieces of fabric together with the right sides facing each other. It is often called an open seam because the two sewn edges are pressed open. The edges of the seam can be neatened separately or together to stop them fraying, using an overlocker or zigzag stitch, for example. If the two edges are overlocked together, this is called a closed seam.

### French seam

This seam is used when you need a small seam that is nearly invisible but strong: for example, on underwear and delicate fabrics such as silk.

## Objectives

- Be able to explain what a seam is.
- Be able to identify which type of seams might be used for different products and fabrics.
- Be able to plan the order of manufacture of different seams, including the use of technical language.

 **Remember**

**Top tip!** Do not get seams mixed up with hems and other edge finishes. A hem is an edge finish that neatens the bottom edge of something, such as the bottom of a trouser leg.

### Key terms

**Seam:** joining two pieces of fabric.

**Construction technique:** techniques with a purpose, not just decorative.

**Seam allowance:** distance from the edge of the fabric when sewing a seam.

**A** When the two edges of a plain seam are pressed open and separately neatened, this is known as an open seam

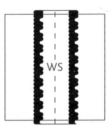

**B** A plain seam that has been pressed open and had both seam edges overlocked

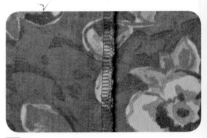

**C** When the two edges of a plain seam are overlocked together, this is known as a closed seam

# Chapter 8 Making

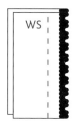

D A plain seam where both edges have been overlocked together to make a closed seam

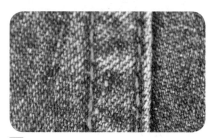

E Run and fell seams are often found on jeans

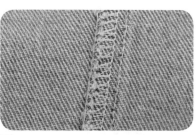

F A mock run and fell seam looks the same as a run and fell seam on the right side of the fabric, but overlocked edges can be seen on the wrong side

It is made in two stages. First of all the fabrics are sewn together with the wrong sides facing each other. The seam is then trimmed down very small and the fabrics turned so the right sides face each other. The seam is then stitched again trapping all the raw edges inside the join.

## Run and fell seam
This seam is often used on jeans, jackets, pyjamas and men's shirts. It is very strong and no raw edges show on the right or wrong side of the fabric. This seam is also known as a flat fell seam or a double stitched seam. It is made working only on the right side of the fabric.

## Mock run and fell seam
This is a quicker and easier version of the run and fell seam and is used in a similar way. It is made by doing a closed seam, which has been pushed to one side and topstitched on the right side, to copy the two rows of stitching found on a run and fell seam.

## Piped seam
This seam gives a decorative effect to a product and gives the seam more structure. It is made by doing a plain seam with piping cord wrapped in fabric and trapped between the seam layers.

### Case study

#### Using technical drawings and notes
Technical drawings and notes are often used to describe how to do techniques. Standard codes are used to show key details.

- RS = right side of the fabric. This is the side that will be visible when the product is used.
- WS = wrong side of the fabric. The inside of the fabric, which will not be visible.
- LS = lock stitch (the industrial word for a straight stitch)
- OL = overlocking stitch
- ZZ = zigzag stitch

You can see examples of how they are used in Figures B and D.

Include these technical codes when you do drawings of how to do techniques.

### Activities
1. Look at a selection of products. Draw a table to compare the different seams on the products. Include columns for
   - the name of the product
   - the fabric it is made from
   - the name of the seam
   - its position on the product
   - an explanation of why this seam is used.
2. Produce a sample of each type of seam described on these pages, and use notes and diagrams to show how you made it.

### Summary
- There are different ways of joining fabrics together: for example, plain seam, French seam, run and fell seam.
- When choosing seams, consider things such as who the user is, what the product and fabric is, and where the seam will be used.

# 8.4 Shaping techniques and pockets

## Objectives

- Be able to explain the terms 'shaping techniques' and 'pockets' and give examples.
- Be able to compare different shaping techniques and pockets, and identify when and where these techniques might be used.

Shaping techniques and **pockets** usually have a job to do, so they are known as **construction techniques**. When you choose these techniques think about the following questions.

- Who will use the product?
- What will it be used for?
- Where will the technique be used on the product?
- What do you want the technique to do?
- What fabrics are being used?
- What equipment and machinery is available?

## Types of shaping techniques

Shaping techniques are used to change a flat 2-D fabric into a 3-D shape. There are different types, depending on the finished result you want to achieve.

### Darts

A dart is a triangular fold in fabric that allows you to shape something permanently (Figure **A**). They are often used to give shape around the bust, waist and hips, but can be used anywhere you want a curved 3-D shape. A dart can have a single point, for example, a bust dart. Or it can have two points, known as a double-ended dart, which is used to shape dresses around the waist and hips, for example.

**A** This dart shapes the bust area of a woman's shirt

### Tucks and pleats

Tucks and pleats are folds in fabric that are held down with machine stitches along the top edge. Pleats can add shaping to products and allow for movement because of the extra fabric. There are lots of different types of pleats, for example, knife pleats (Figure **B**), box pleats and inverted pleats.

### Gathers

Gathers are made up of lots of tiny pleats sewn into a seam. They give extra fullness, for example, around a waistline, or at the top of curtains. Elastic can also be used to gather up a section of fabric.

**B** Knife pleats are folded so that all the edges face in one direction

### Smocking

Smocking is a way of changing the shape of fabric decoratively. Gathers are used to pull the fabric into folds. These are then held in place with hand or machine embroidery stitches. Smocking is often used on children's dresses.

### Key terms

**Shaping techniques:** darts, pleats and gathers, which change a flat 2-D shape to a 3-D shape.

# Types of pockets

Pockets are functional, as they are used to carry things. They can also be decorative, especially when they are made into a feature rather than being hidden away. Pockets can also have flaps, which adds to the decorative effect and makes them more secure.

## Patch pocket

A patch pocket is made of a piece of fabric that is topstitched on to the surface of a product. Patch pockets are often found on the back of jeans (Figure C).

**C** Patch pockets are very popular on the back of jeans

## Welt pocket

A welt pocket has the pocket opening strengthened by a welt (Figure D). This is a band of fabric that sits across the top of the pocket. The pocket itself is invisible and sits inside the product. It can be used on jackets and trousers.

## In-seam pocket

This pocket is sewn into the seam of a product, which means it is invisible. The pocket bag sits inside the product. It is often used on the sides of skirts, trousers and jackets.

**D** Welt pockets are often found on suit jackets

## Hip pocket

A hip pocket sits on the hips and has a curved top edge. It is often found on skirts and trousers.

### Activities

1. What shaping technique would you recommend for the following products? Give reasons for your answers.
   - Adding fullness to the waistline of a man's pair of trousers.
   - Shaping a blouse to fit closely around the bust.
2. Pockets can be both functional and decorative. Look at Figures E and F to see two examples of this. Look at a range of pockets you and your friends are wearing, and identify whether they are decorative, functional or both.
3. Design a jacket that has at least two different styles of pocket as part of the design. Explain the purpose of each pocket.

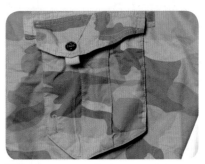

**E** This pocket is both functional and decorative. It has a flap with a fastening, and this makes it more secure. It also has an inverted pleat down the centre, making it more 3-D, so it will carry more.

### Summary

- Shaping techniques are used to make a flat fabric have a 3-D shape.
- Pockets can be both functional and decorative.
- When choosing these techniques, think about who the user is, what the product and fabric are, and where the technique will be used.

**F** This fun pocket is hidden away inside the hat design. It is fastened with a zip and is being used as a selling feature to appeal to the buyer.

# 8.5 Finishing and fastenings

## Objectives

- Be able to explain the terms 'edge finishes' and 'fastenings' and give examples.
- Be able to compare different edge finishes and fastenings to each other, and identify when and where these techniques might be used on different products.

## Key terms

**Edge finishes:** techniques that neaten the outer edges of a product so that they do not fray or go out of shape.

**Fastenings:** used to close an opening, or to hold something together that needs to be closed temporarily.

Edge finishes and fastenings are both construction techniques, as their main purpose is to do a job rather than just be decorative.

When you choose these techniques think about the following questions

- Who will use the product?
- What will it be used for?
- Where will the technique be used on the product?
- What fabrics are being used?
- How do you want the technique to behave: for example, do you want it to be strong, do you want it to be invisible?
- What do you want the technique to look like on the right and wrong sides when it is finished?
- What equipment and machinery is available?

## Edge finishes

Edge finishes neaten the outer edges of a product so that they do not fray or go out of shape: for example, around the bottom of trousers and around sleeve or neck edges.

### Hems

Hems are a fold of fabric turned to the wrong side of the product and stitched into place. The stitching can be done by hand or machine, and can be visible or invisible, depending on the product. For example, jeans hems are often done in a coloured thread, but the hem on a wedding dress is usually invisible.

### Lining

A lining is used inside a product to hide the seams. It can also be used to make clothes warmer. Linings can be found on any product, but are particularly popular on jackets, coats, skirts and curtains.

### Facing

A facing is often used around the edge of jacket fronts, necklines, armholes and waistbands. It is a thin band of fabric, cut to copy the shape of the edge it will neaten, and it is sewn inside the product. Facings often have interfacing inside them to make them stronger (Figure **A**).

### Binding

A binding is a thin strip of fabric that wraps around the edge of the fabric. It can be sewn on so it is visible or invisible (Figure **B**).

### Other edge finishes

Waistbands, collars and cuffs can also be used to neaten off the edge of a product.

**A** This image shows a facing neatening the armhole on a child's top. The edge where the buttonholes are is also neatened with a facing.

Chapter 8 Making

# Fastenings

Fastenings are used to close an opening, or to hold something together that needs to be closed temporarily. They can be hidden or be decorative.

## Zips

Zips are a very strong fastening. They can be made to be invisible or decorative. Open-ended zips open all the way down to the bottom, such as those used on jackets. Closed zips only open at one end, such as those used on trousers. A special zip foot has to be used on the sewing machine when applying zips.

## Buttons and buttonholes

Buttons come in a wide range of sizes and shapes. They can be fastened by using a buttonhole or through loops attached to the fabric (Figure **C**).

## Other fastenings

Poppers, and hooks and eyes, are good to use where the fastening needs to be small but does not need to be very strong (Figure **D**). They can be bought individually or on a long tape. Buckles, velcro, clips, ties and eyelets are other types of fastenings.

### Link

A range of components are used when doing edge finishes and fastenings, including binding, zips and buttons. For further details on these, see **7.8 Textile components**.

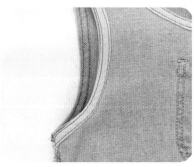

**B** Binding has been used to neaten the armhole. The binding has been applied so it is on the inside of the product and cannot be seen on the outside.

**C** Buttons and buttonholes come in all shapes and sizes. This button is called a toggle and has a buttonhole made of a loop of cord.

**D** Poppers snap shut and are often used on children's clothes, as they are easy to open quickly

### Activities

1. Look at four different products. In a table, summarise the different edge finishes and fastenings that have been used on these products. Include headings in your table for the name of the product, the name of the technique used, where it is on the product and why that technique has been chosen.

2. What finishes would you recommend for the following edges? Give reasons for your answers.
   - The neckline of a T-shirt for a teenage boy.
   - The bottom edge of a skirt.

3. What fastenings would you recommend for the following products? Give reasons for your answers.
   - A ski jacket.
   - A babygro.

### Summary

- Edge finishes neaten armholes, necklines, and other edges, for example, hems and bindings.
- Fastenings allow something to be opened and closed, examples are zips and poppers.
- When choosing these techniques think about who the user is, what the product and fabric are, and where the technique is used.

# 8.6 Colouring fabric

## Objectives

- Understand some of the different methods of adding colour to fabric.

## Key terms

**Dyeing:** immersing fibres, yarns or fabrics into a pigment dye to change the colour.

**Pigment:** the name of the colouring matter used in the dyeing process.

**Fixative:** a chemical (usually salt) added to make sure that a dye is fixed.

**Mordant:** the industrial term for a fixative.

**Resist dyeing:** a method that means the dye is prevented from getting to certain parts of the fabric in some way.

**Tjanting tool:** a specialist batik tool designed to carry and apply hot wax to fabric.

## Link

See **8.7 Fabric printing** for more on printing.

People are generally drawn to textiles because they are colourful and attractive. Most fabrics start out as beige or white, so it is important to be able to apply colour to offer the wide array of colours and patterns that consumers like.

One way to add colour to fabric is called **dyeing**. The other main way to add colour is by printing.

## Dyeing

Colouring fabrics in this way has been done for centuries. Natural fibres could be dyed using natural dyes, such as beetroot, beetles, and plants like heather and lichen. This method was ideal, as the source of the dye was renewable and the process was very natural too. The drawback was that the dye could be uneven and inconsistent. Modern man-made fibres do not absorb these natural dyes in the same way, so new chemical dyes have been introduced, which create a more consistent colour.

Dyeing textiles is achieved by immersing fibres, yarns or fabrics into a **pigment** (usually dissolved in water). A **fixative** or **mordant** is added to make sure that the fabric keeps its intended colour.

### Tie dyeing

This method of dyeing is known as a **resist dyeing** method. This means that the dye is prevented from getting to certain parts of the fabric. In tie dyeing, resists are created by tying string or elastic bands around the fabric. This can be done in varying ways to create lots of different effects (Figure **B**).

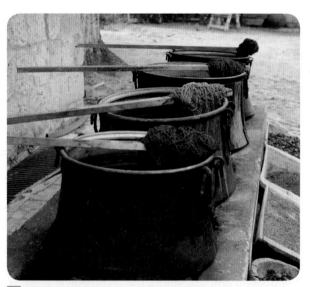

**A** Fibres being dyed naturally, ready for making carpets

The tied fabric is washed in clean water, then immersed in a dye bath with a desired colour, and left for the required time for the pigment being used. It is very important to rinse the fabric before removing the string or elastic bands. Once the water runs clear you know that the colour is fixed. You can then untie the fabric. If you wish, you can repeat the process using different pigments for a multi-coloured effect.

## Batik

The batik technique is a very old method, traditionally used in Africa, India, China and Japan. The resist in this method is created by using hot wax, which is removed after the dye has been applied. The wax can also be cracked once it is cool. To create veins where the dye can seep in to give a marbled effect (Figure C).

B Girl wearing a two-colour tie-dyed T-shirt

The wax is applied using a *tjanting tool* (pronounced janting) which is specially designed to carry and apply the hot wax.

### How to do batik

1 Draw a design on a piece of paper then transfer the design on to the fabric using a fabric pencil or marker.
2 Stretch the piece of fabric over a frame and tack it in place. Alternatively, place newspaper under the fabric.
3 Melt the wax in a suitable pot. Apply the hot wax to the drawn areas on the fabric using a tjanting tool.
4 After allowing the wax to cool, take the fabric and immerse it into a colour dye mix of your choice. Alternatively, batik dyes can be hand painted into the different waxed sections. To build up colour in your design, use a light dye first, then add more wax and another colour.
5 Once you have finished your design, iron the fabric between two sheets of absorbent paper to remove the wax.
6 You can then wash your fabric and the colours and design will remain.

C Traditional batik design clearly demonstrating the marbling effect

### Remember

You must always follow the health and safety guidance for using dyes and hot wax.

Eye protection, an apron and hand protection should be worn when you are working with dyes.

You must use the correct equipment, and only attempt these tasks after a demonstration by your teacher.

### Activities

1 After mixing a dye following the manufacturer's instructions, try dyeing a plain piece of cotton fabric.
2 Try dip dyeing a piece of cotton fabric. To do this:
- immerse the fabric into the dye for about 10 minutes
- lift a small section of the fabric out of the dye
- leave the rest of the fabric in the dye for another 10 minutes
- lift another small section out
- repeat until all of the fabric is out of the dye.

  You should be left with stripes of different depths of the dye colour.
3 Experiment with creating different tie dye effects.

### Summary

- There are many different methods to add colour to fabric.
- The methods featured here give you some good examples of ways that can be easily used in a classroom.

# 8.7 Fabric printing

## Objectives

- Understand the basic printing methods used in textiles.
- Know how to create a simple block print.

Fabric printing is a fun way to add colour and pattern to your textiles and can be done using various methods. We will look at some of the more basic methods that are easy to achieve in a classroom. The advanced and industrial methods are often costly and difficult to set up in a classroom owing to the large areas of space and the specialist equipment needed.

## Block printing

**Block printing** is probably the oldest and most accessible method of printing because of the simplicity of the process and the small amount of equipment needed.

The first thing you need is a **design** or **print block**. The first design blocks were carved out of wood using sharp tools such as knives. The raised areas of the wood were called a *relief*, which means that some areas are raised higher than others.

In the classroom, a design or print block can be created using many different materials including lino, card and string, or even a potato! As long as you create a relief that is even your design will print. Designs for your print block can be drawn on paper or created on the computer using CAD software. If you have access to a CNC miller or laser cutter you can cut your design directly out of lino.

The relief is coated with dye. The block is then pressed down on to fabric and the dye leaves a print of the relief. The process can be repeated to create what is called a *repeat pattern*.

## Screen printing

The second most common form of printing is **screen printing**. Screen printing requires a little more skill and specialist equipment. If you have ever used a *stencil* and painted through it in order to leave a design, then you will already have a simplified idea of what screen printing is.

The design is cut out of a thin piece of film or paper to create a stencil. A screen is made by covering a frame, usually wooden or metal, with silk or nylon. The stencil is then attached to the frame so

### Activity

1 Try creating a block print.

- You will need materials to make your block: a piece of a polystyrene foam food tray would be fine. Press your design into this by using a pencil. The areas pressed in will not print, so think about your design carefully.
- You will need printing inks and a roller.
  1 Roll out your ink on to a suitable surface (you will need to clean this afterwards so do not use anything porous).
  2 Roll the ink on to your block, covering it evenly.
  3 Then turn the block over on to a piece of plain white cotton fabric and press down firmly.
  4 Trying not to move the block, rub the back of the block gently with medium pressure.
  5 Lift the block off and it will have left your design.
- You can repeat this process to create a repeat pattern.

**A** Wooden print blocks for printing by hand

**B** Screen printing a check design

that it is lying on top of the screen. Then with the stencil facing down on a piece of fabric you are ready to print.

Specialist inks or dyes are used for screen printing so that they can pass through the mesh of the screen and be easily cleaned off afterwards. You place some of the specialist printing ink or dye at the top inside of the screen, leaving about 2.5 cm from the top of the frame so you can fit the squeegee in. The squeegee is a thin piece of wood with rubber attached to the edge that will fit just inside the frame. Holding the squeegee at about a 45 degree angle, and with even pressure, you can pull the ink or dye across the screen (Figure B). The colour will have been pushed through the stencil, only printing in the areas that had been cut out.

You can start by printing your lightest colour first, and then build up your design by adding further colours and detail. You will need a new stencil for each colour and pattern or detail. Flatbed printing is the industrial method of screen printing.

## Other methods of printing

Other methods of printing include **roller printing** and **transfer/sublimation printing**.

Roller printing is basically the industrial version of block printing, but using engraved copper rollers instead of a block. The rollers run over the fabrics to print the design. Each roller adds a further colour and detail to the fabric. Using this method, hundreds of metres of fabric can be printed continuously.

Transfer printing is a method where a dye printed on paper changes from a liquid to a gas or vapour when heat is applied. The vapours meet the fabric and turn back into a solid state having transferred to the fabric. This method works best on synthetic fabrics.

Transfer printing requires a computer, sublimation printer and a heat transfer press. However, in the classroom you can create similar results with fabric crayons and sublimation pens, using an iron to create the heat.

### Case study

#### Harlequin

Harlequin produce high quality printed fabrics and wallcoverings for the domestic and commercial interiors market. They have a range of innovative and exciting products that make use of the wonderful effects you can get with industrial printing.

- What do you think are the main advantages of printing industrially rather than by hand?
- When might printing by hand be better?

### Key terms

**Fabric printing:** a way of transfering colour and pattern onto fabric.

**Relief:** some areas of a design are raised higher than others.

**Repeat pattern:** a pattern reproduced uniformly across a surface.

**Stencil:** a thin sheet of material with a shape cut out of it, through which paint or ink is applied to mark the shape on to another surface.

**Squeegee:** a thin piece of wood with rubber attached to the edge, which is used to evenly push dye through a silk or nylon screen designed for printing.

C Printed interior fabrics and wallcoverings by Harlequin

### Summary

- There are many forms of printing that are fun ways of adding colour and pattern to textiles.

# 8.8 Appliqué

## Objectives

- Be able to describe different types of appliqué.
- Be able to identify useful tips and quality control points when carrying out appliqué.

## Key terms

**Appliqué:** stitching one piece of fabric on to another using hand or machine stitches.

**Interfacing:** often used under appliqué designs to strengthen them and stop shapes from stretching.

**Reverse appliqué:** layers of fabric are stitched together, and the top layer is cut away to reveal the layers underneath.

## Activity

1. Design a product that uses appliqué to add decoration and colour to the item. Say who the product is for, and name the type of appliqué you have used. Make sure it is clear on your design where the appliqué will be on your product.

   - Use notes and diagrams to explain how the appliqué you have designed would be manufactured. Include quality control points and useful tips as part of your answer.

**Appliqué** is where fabric is sewn on to another piece of fabric using hand or machine stitches. It is mainly used to add decoration and colour, but can also have a function, for example, to strengthen or repair the knee area on children's trousers.

## Things to think about when doing appliqué

- Choose fabrics that will behave in a similar way when used, washed and ironed. This means the appliqué will last a long time.
- The design and choice of appliqué must be suitable for the user, the product, and the position it will be used in.
- Think about the finished effect that is required: for example, is it decorative or functional (such as strengthening or repairing an area)?
- **Interfacing** can be used under appliqué shapes to make them firmer and to help stop them from fraying. It can also be used under the background fabric to prevent it from stretching. Wadding can also be used under each shape to make the appliqué stand out.

## Types of appliqué

### Machine appliqué

Machine appliqué is the most common type, as it is quick and easy to do. A close zigzag stitch is often used to do this type of appliqué.

### Hand appliqué

Sewing appliqué by hand is time consuming, and stitching must be neat. Stitches are used that will seal the edges and stop them from fraying, for example, blanket stitch or satin stitch.

**A** This appliqué has been machined with a close zigzag stitch to hold it in place. Wadding has also been put underneath to give a slight padded effect.

**B** This traditional Peruvian hand appliqué uses blanket stitch to hold down the appliqué shapes

## Reverse appliqué

**Reverse appliqué** is done the opposite way round to traditional appliqué. Instead of layers of fabric being built up on a background fabric, the layers of fabric are stitched together, then the top layer is cut away to reveal the fabric beneath.

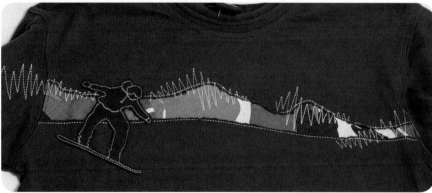

C  The top layer of red fabric has been cut away to reveal the camouflage fabric underneath. The skier design is done using ordinary appliqué and sits on top of all the other fabrics. Decorative embroidery stitches have also been used on the design.

### Case study

#### Drawstring bag

This bag shows different types of appliqué. The centre of the flower is done using traditional machine appliqué techniques, with a tight zigzag stitch. The outer rim of the flower is done in the same way, but the edges have been left to fray for an decorative effect. Fabric and braid have also been appliquéd around the top of the bag using a lock stitch.

The appliqué techniques used on this bag are for decorative purposes. What construction techniques can you also see on this bag?

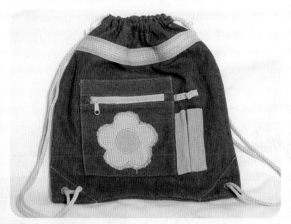

D  This bag shows several types of appliqué

### Summary

- Appliqué is sewing one fabric on to another using hand or machine stitches.
- It adds decoration and colour and can be functional, for example, strengthening or repairing an area.
- Reverse appliqué is where the top layer is cut away to reveal layers underneath.
- When doing appliqué, you should choose fabrics that behave in the same way as each other when washed and used.

# 8.9 Quilting and patchwork

## Objectives

- Be able to describe different types of quilting and patchwork.
- Know the useful tips and quality control points when carrying out quilting and patchwork.

## Key terms

**Quilting:** several layers of fabric are sewn together to produce a 3-D padded effect.

**Wadding:** padding used in the centre of quilting to give a 3-D padded effect.

**Patchwork:** pieces of fabric are sewn together to make a new piece of fabric.

**Quilting** is where several layers of fabric are sewn together to produce a 3-D padded effect. **Wadding** is usually a thick, fluffy layer of fabric that is used for the padding. Ordinary fabric can also be used, depending on how padded the finished effect needs to be. Quilted fabrics are warm, and are often used for coats and clothing. They can also provide protection, such as when used in oven gloves.

**Patchwork** is where pieces of fabric are sewn together to make a new piece of fabric. It was traditionally a way of recycling materials or using up leftover scraps of new fabric. Patchwork is often used to make bed covers and cushions, but it can also be used in a range of other products.

Patchwork and quilting are often combined in products and work well together.

**A** Patchwork is not only used for bed covers and cushions, but can be used for a range of other products

## Things to think about when doing quilting and patchwork

- Choose fabrics that behave in a similar way when used, washed and ironed. This means the products will last a long time.
- The design and choice of technique must be suitable for the user, the product, and the position it will be used in.
- Think about the finished effect that is required. For example, how will colour and pattern be combined in a patchwork? How thick does the quilted effect need to be?

## Quilting

Quilted fabrics have to be prepared carefully so the layers do not move when sewn. Because of this, the layers of fabric are often clipped into a frame when being sewn. As the stitches will be visible, the choice of stitch and thread are important.

**B** Italian quilting showing padded channels

**C** Trapunto quilting, where sections of the design have been padded from behind

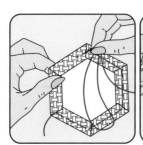

**D** How to do English patchwork

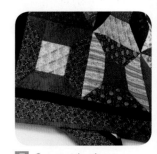

**E** Geometric shapes sewn together in blocks to produce a patchwork fabric

### English quilting
This consists of a top layer of fabric, a layer of wadding, and a backing layer of fabric. The fabric is stitched with a design that gives the fabric a 3-D appearance on the surface.

### Italian quilting
Instead of wadding, a padded yarn is inserted between rows of parallel stitches to give a padded channel. The rest of the fabric remains flat.

### Trapunto quilting
This is where sections of a design are slashed open on the back of the fabric and are stuffed from behind. This gives the design a more 3-D effect.

## Types of patchwork

### English patchwork
This is traditionally done by hand. Paper templates have fabric wrapped over them and are temporarily held down with tacking stitches. The edges are joined with small oversewing stitches and the paper shapes are removed afterwards. This method is time consuming to do.

### American block patchwork
This method can be done by hand or machine. Geometric shapes are joined together using an open seam. Individual squares of patchwork, called blocks, are made. These are then joined together. The surface of the patchwork is also often quilted.

### Crazy patchwork
This is the most economical type of patchwork, as any shape or size of fabric can be used. Fabrics are stitched to a backing fabric using a hand or machine stitch. This technique is similar to appliqué, but the patchwork effect covers the whole fabric and not just one area.

## Activities

1. Colour and pattern can be used in patchwork to create a 3-D visual effect. Use geometric shapes to create a patchwork fabric design of your own.

2. There are other types of patchwork and quilting as well as the ones mentioned on this page, such as Suffolk puffs, clamshell patchwork and log cabin patchwork. Do your own research to find out about at least one of these techniques.
   - What does the technique look like?
   - What products is it used on?
   - How it is made?

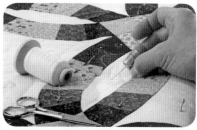

**F** An Amish handmade quilt using a traditional double wedding ring design

## Case study

### Patchwork quilts: an American tradition

Traditionally, the making of patchwork quilts was a popular American social pastime. Handmade quilts were often given as wedding gifts and were handed down through generations of a family. Quilts were often made using waste swatches of fabrics from memorable products from someone's life, and were of great sentimental value because of the memories attached to the fabric.

The American Amish people are famous for their geometric patchwork quilts, which use recycled materials and are functional, but also provide a way for people to socialise and entertain themselves.

- Do your own research on the American Amish community to find out about their traditional patchwork quilts.

## Summary

- Quilted fabrics use wadding and stitches on the surface to create a 3-D padded effect.
- Patchwork fabrics are made by sewing shapes together to make a new material.
- These techniques are often combined in products such as bed covers.
- Fabrics should behave in the same way as each other when washed and used.

# 8.10 Embellishment

## Objectives
- Be able to describe different types of embellishment.
- Know the useful tips and quality control points when carrying out embellishment techniques.

Embellishment is the name given to different techniques that are applied to the surface of a fabric to decorate it and give it a 3-D textured effect. Any product can be embellished, and the embellishment can be just for decoration or can have a purpose, such as badges on uniforms to show a group's identity (Figure A).

## Things to think about when embellishing fabrics
- Choose fabrics and components that behave in a similar way when used, washed and ironed. This means the products will last a long time. Note that some components used for embellishing fabrics cannot always be washed easily, such as sequins and beads.
- The design and choice of technique must be suitable for the user, the product, and the position it will be used in: for example, sequins and beads would be a safety hazard for babies.
- Think about the finished effect that is required, for example, some types of embellishment make the fabric heavier and stiffer.

## Types of embellishment

### Embroidery
Hand embroidery is one of the oldest ways of embellishing fabrics (Figure C). Different effects can be achieved depending on the threads and stitches that are used. Embroidering by hand is very time consuming and not very suitable for large-scale production. However, embroidery can now be done on computer-controlled machines that can produce effects identical to hand embroidery (Figure D).

### Ribbons, lace and braids
There is a wide range of ribbons, lace and braids that can be used to embellish products. These can be sewn down by hand or machine (Figure E).

### Sequins and beads
There are a variety of different types of sequins and beads available to embellish fabrics with. They add colour and texture to a fabric as well as light-reflecting qualities (Figure F). Buttons, shells, mirrors and feathers can also be used in the same way.

It can be very time consuming to attach sequins and beads by hand, and this can add to the cost of a product. Some sequins and beads can be applied to fabrics using machines. Special fabric glues are also available to hold some of these embellishments in place.

Sequins and beads cannot always be washed easily, as they can get damaged, so products with them on may be harder to care for.

### Key terms
**Embellishment:** different techniques that are applied to the surface of a fabric to decorate it and give it a 3-D textured effect.

A Embellishment can have a purpose as well as being decorative

### Link
See **7.8 Textiles components** for more on some of the components used to embellish fabrics.

Chapter 8 Making

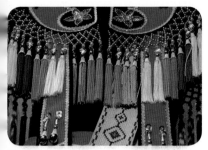
B Highly embellished traditional tribal dress

C Hand embroidery

D Machine embroidery

E Ribbons and braids can be used to embellish fabrics

F Box decorated with sequin embellishment

### Link

See **8.2 Using a sewing machine** for more on CAD CAM embroidery.

## Case study

### Shisha work

Shisha work is also known as mirror work. It is an Indian style of embroidery where small mirrors are sewn on to fabric. It is used on a variety of products from clothes, hangings and bags, to interior products. The mirrors reflect light and colour and add texture and interest to products. They can be bought loose or with an embroidered ring already around them, which makes it easier to sew them down.

- Try using small coins, buttons and other similar items in your work. Hold the items down with embroidery stitches.

G Shisha work using mirrors and embroidery to embellish fabric

## Activities

1. Embellishing a fabric or product can make it more expensive to buy. Why do you think this is?
2. Can you think of any other negative aspects of embellished products?
3. Design a product that uses lots of different embellishment techniques. Label your design to show:
   - the types of embellishment you have used
   - the techniques and materials you would need to add this embellishment.

## Summary

- Embellished fabrics use different techniques to decorate the surface.
- Embroidery, beads, sequins and appliqué are all different types of embellishment.
- Embellishing a fabric can make it more difficult to look after, as some types of embellishment are hard to wash and iron.

# 8.11 Manufacturing in industry

## Objectives

- Understand how manufacturing in industry is different to making in the classroom.
- Be able to identify some of the production methods used in industry.

### @ Link

See **4.3 CAD** and **5.3 CAM** for more on CAD and CAM.

Making a textiles product in the classroom is quite different to making a textiles product in industry. In the classroom, you only need to worry about yourself and the product you are making. If you make a mistake, you simply put it right. In industry, many other people and factors affect the making of products, and an error could cost a company thousands of pounds. Manufacturers go to great lengths to avoid making mistakes: they put checks in place to ensure the quality of a product. These checks are called **quality control** points or QC.

## Production methods

### Production lines

In industry, products are usually made by passing each stage of making down a line: this is known as a **production line**. At each stage of making, a specific operator or machinist carries out a required task, then passes it on to the next machine or person to continue making the product.

### Mass production

The main difference when making textiles products in the classroom, rather than in industry, is the volume and speed at which products are manufactured. **Mass-produced** items are normally created in high numbers with machinery that is rarely stopped, as it is very costly to stop and restart production (Figure **A**). Computer-aided design and computer-aided manufacture (CAD CAM) are used wherever possible to cut down on labour and speed up the process. The benefit of producing products in high volume is that large companies, with high-demand products, can replenish stock easily.

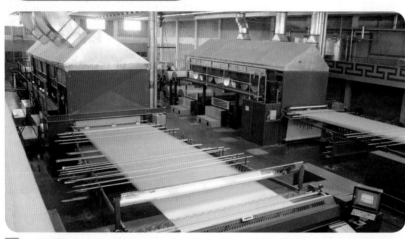

**A** Mass production of cotton fabric

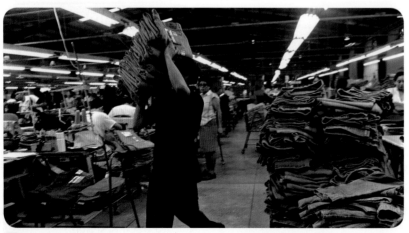

**B** Jeans being made using the production line method in batches

## Batch production

Unlike mass production, **batch production** is when textiles products are made in quantities responding to an order or demand (Figure **B**). The machinery does not have to be continuous, so if a design needs to change slightly, it is not as costly to stop and make the changes as it would be for mass production. The benefits of using batch production are that you can change designs, or order quantities, to suit the demands of the customer.

## One-off production

This method is probably closer to what you would do in the classroom, as only one product will be made. A **one-off** product is usually made by one or more skilled people who tailor the product directly to the customer's needs. This is termed **bespoke** (Figure **C**). Designer products you see on the catwalk, or **haute couture**, are made in this way. They normally command a high price, as they have only been created once, and no other person will have one exactly the same. The added benefit is that they are made specifically for the customer, so they fit perfectly and suit their style.

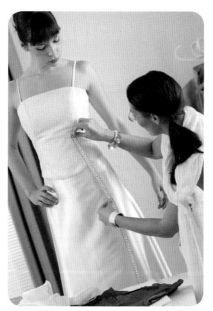

**C** A one-off bespoke design being made to a client's measurements

### Key terms

**Quality control:** these are check points to test, or double check, that a product is being made accurately.

**Production line:** in industry, products are usually made by passing each stage of making down a line, using both manual and mechanised methods.

**Mass-produced:** items are normally created in high volume numbers with specialised machinery that is rarely stopped.

**Batch production:** when textiles products are made in specific quantities, or with requirements responding to an order or demand.

**One-off:** the product is usually made by one or more skilled people, who tailor the product directly to the customer's needs.

**Bespoke:** the product is made directly to the individual customer's needs, so it is unique.

**Haute couture:** a French term referring to high fashion, high quality, bespoke clothing

### Activity

1. Decide in your class on a simple textiles product you could make, such as a simple zipped purse. Note down all the things you would need to consider, including equipment, if you were to make 20 of these.

   - Create a production line, giving each person a stage in the making to do.
   - Remember to think about quality. You can add in some quality control points that everyone should be aware of and follow.
   - Time yourselves to see how long it takes you to make the 20 items.
   - Evaluate your products. Are they all of the same quality? Are they well made?
   - Following your production line, note down what went well and what did not.
   - Make suggestions for how you could have improved the process.

### Summary

- Manufacturing in industry produces high volume products to make a profit.
- One-off items are normally tailored for a specific individual. They are expensive and completely unique.

# Chapter 9  Case studies

## 9.1 Famous designers

### Objectives
- Recognise some of the famous designers' names and what they are famous for
- Understand the difference between a brand name and a designer.

### The role of a designer

All your clothes are designed, whether it is by a designer who is famous or not.

Fashion **designers** either work alone or as part of a team. They will design clothing for a target market (such as teenagers, children, women or men) thinking about what is fashionable and what the function of the clothing is.

They need to be able to look at old styles and see a new direction to take with their designs. From sketching to making, fashion designers need artistic ability, strong textiles skills and originality to succeed in the industry.

They take on the tasks of:
- creating sketches and designs
- choosing materials
- making prototypes (models)
- going to fashion shows to look for the latest trends.

### Famous fashion designers

Some fashion designers set up their own label or **brand**, and their products are sold throughout large department stores or through manufacturers. As they become more popular, their names become well known.

Some well-known labels include:
- Calvin Klein
- Gucci
- Chanel.

**Famous designers** are often the director of their company and have a large team of designers and manufacturers to produce their products.

Their new ideas go to fashion shows or events, where models display their products on **catwalks**. Often the most famous designers will design garments especially for an individual who is willing to pay a lot of money for a unique outfit.

### Activities

1. Choose one of the designers featured on this page.
   - Create a mood board of their designs and the things that inspired them.
   - Use these ideas to inspire a design of your own. For example, you could design your own check pattern in the style of Burberry's famous classic check.
2. Choose another famous designer you have heard of, and do some research on their designs. You could present your findings to the class.

### Key terms

**Brand:** the name or other characteristics by which a product is identified.

**Famous designer:** a designer whose products are well known by the public.

**Catwalks:** where models walk on a stage showing the outfits they are wearing to the public.

### Summary
- To become a famous designer you need to be artistic, original and skilled at working with textiles.
- Fashion designers also need business knowledge in order to create a brand which will sell.
- Brand names make products recognisable and popular with the public.
- Famous people often promote designers' work.

# Classic British design

## Case study

### Burberry

This company was founded in 1856 in Basingstoke by Thomas Burberry, who was only 21 years old.

Burberry specialises in clothing and accessories, and is known for its fashionable bags. The company invented gabardine, which is a hard-wearing, breathable and waterproof fabric.

One classic Burberry design is the trench coat, which was extremely fashionable during the First World War and afterwards. The trench coat had a lining, for which Burberry developed a check pattern called Burberry classic check. This check has been used as part of many Burberry products.

The brand has a very classic British identity. It uses British celebrities for its advertising, including Kate Moss, Agyness Deyn and Emma Watson.

A The Burberry classic check

## Case study

### Vivienne Westwood

Vivienne Westwood is one of the most recognisable British designers of the past 40 years.

She began designing clothes in 1971, and opened her first shop, Let It Rock, at 430 King's Road in a fashionable part of London. The shop sold clothing and accessories relating to the punk era. Vivienne and her partner, Malcolm McLaren, designed outfits that promoted the punk band the Sex Pistols.

Nowadays, she is well known for designing haute couture – quite a change from the punk clothing that started her career! In recent years she was awarded an OBE for her services to the fashion industry.

B T-shirt designed during the punk era

## Case study

### Zandra Rhodes

Zandra Rhodes also designed during the punk era in Britain. At the time, some of her designs were seen as shocking by the public. For example, she used safety pins rather than sewing to construct her garments.

Her designs were considered to be more dramatic and feminine than Vivienne Westwood's. She is mostly famous for her bold colours, especially pink!

Rhodes designed clothing for Diana, Princess of Wales, and Freddie Mercury from the band Queen.

She was awarded a CBE in 1997.

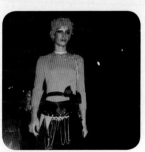

C Zandra Rhodes is known for designing outfits in pink

# 9.2 Designing for others

## Objectives

- Understand that fashion products are designed for different types of users.

### Link

See **8.11 manufacturing in industry** for more on bespoke products.

### Key terms

**Made-to-measure:** one-off garments made for individual people.

**Ready-to-wear:** collections of garments made by a designer or a brand.

**Mass market:** large quantities of clothing made in standard sizes.

When we design, we do not just do it for ourselves, we design for other people's needs too. We must take into consideration whether we are designing for an individual, or for groups of people.

## Made-to-measure (haute couture)

This is a product that is made for one person as a **bespoke** item. Being bespoke means the garment is made entirely to the customer's specification. A **made-to-measure** garment will be much more costly than a mass-produced item. High quality fabric is used, and the product is made with extreme care and detail.

## Ready-to-wear

This type of product is not made for individual customers, but smaller quantities are produced as collections. These are usually displayed or promoted on the catwalks throughout the world. They tend to consist of outfits that have matching accessories such as trousers, jackets, bags and scarves. A lot of care is taken over the choice and cut of the fabric, and **ready-to-wear** designer items are still very expensive.

## Mass market

The production of large quantities of ready-to-wear clothing, in a variety of size choices, is intended for the **mass market**. Cheaper materials and simpler machine production processes are used, and adapted to the current fashion trends. The trends of these clothes are usually a season behind the designer collections.

### Case study

#### Made to measure: Catherine Walker's 'Elvis' dress

A famous example of a made-to-measure dress is the one that Catherine Walker designed for Princess Diana in 1989, known as the 'Elvis' dress. Catherine Walker designed dresses for the princess from 1981, during her first pregnancy, until her death in 1997. Each dress was exclusively designed for the princess to wear on state visits or special occasions.

The 'Elvis' dress, (which is now displayed at the V&A in London) was made mostly of silk, with pearl beads. The dress was an ankle length, slim design in white, with oyster pearls and sequins sewn all over. It had a cropped bolero jacket, with elbow length sleeves and a stand-up collar, which copied the collars Elvis Presley used to wear. It was first worn by the princess to the British Fashion Awards in October 1989 and then on a visit to Hong Kong.

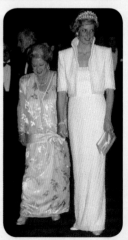

A The 'Elvis' dress

Chapter 9 Case studies

## Case study

### Ready-to-wear: Gucci Fall/Winter 2010 Collection

Gucci was founded in 1921 and produced mostly fashion and leather goods. There is a lot of history surrounding Gucci, and they have created one of the most famous brands in the world.

Their fall/winter 2010/2011 collection was designed by Frida Giannini. Her designs have a sophisticated, modern and luxurious style. The range in this collection included over-the-knee boots, animal prints and furs and materials in lace, sheer or chromatic. New trends, such as fur blouses, see-through cocktail dresses and short suit blazers, were among the choices available.

These collections are generally cheaper than the made-to-measure designs, but they are still expensive and good quality, and are often only available for a short period of time, owing to the fast-moving fashion trends. They are often the clothes of choice for celebrities. Victoria Beckham is known to be a big fan of Gucci clothing.

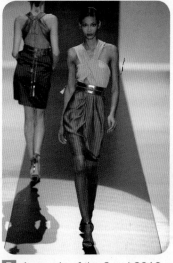

**B** A sample of the Gucci 2010 RTW collection

## Case study

### Mass market: Primark

Primark is one of the biggest mass-market retailers. They sell extremely affordable clothes to the general public. They use cheaper fabrics and production processes to make their clothes affordable, and cater for a wide range of tastes, age groups and sizes, in order to make as much money as possible.

Primark, and other mass-market companies, aim to stock catwalk designs at a fraction of the price of top fashion designer clothing, so that the public can imitate the catwalk style.

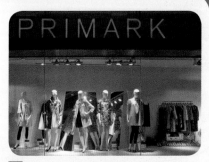

**C** A sample of Primark's affordable clothing

## Activities

1. What are the main differences between these three different types of design?
2. Why do different types of people buy their clothes from these different types of designers?
3. Design your own outfit in one of these different styles of design. Label your design with the features you have used, and explain why you have used them.

### Summary

- Different groups of people have different needs.
- Fashion products are designed in different ways to meet the needs of specific groups of people.

# 9.3 Product development

Footwear has various different functions. It helps us to walk on different surfaces, protects our feet and keeps out the rain.

Wellington boots have been around for two centuries. Over the years, they have developed in response to the needs of consumers, and as a result of the development of new technologies, which have made the changes possible.

## Objectives

- Understand how products develop over time in response to the needs of the consumer
- Understand the role that new technologies play in this development process.

## Key terms

**New materials:** newly discovered or invented materials.

## Activities

1. Think of another example of a product which has changed over time. Say what you think was the main reason for the development of the product in the case study.
2. Design a pair of wellingtons for yourself, which meet your own personal needs.

## Case study

### The development of the wellington boot

#### The Duke of Wellington

The wellington boot was based on the Hessian boot worn by the first Duke of Wellington in the early 19th century. He instructed his shoemaker, in London, to modify the boot to be made of soft skin leather, and for all the trimming to be removed so that it would fit closer to the leg.

This design was intended to make the boot both hard-wearing for battle and appropriate for evening wear.

**A** The first wellington boots, in a cartoon of the Duke of Wellington

#### The first rubber wellington boot

Hiram Hutchinson met Charles Goodyear in America in 1852. Charles Goodyear was responsible for the manufacture of rubber. Hutchinson bought the **patent** to use this material for footwear. He set up a company in France called Aigle Wellington Boots.

In 1856, an American named Henry Lee Norris introduced the first wellington into Scotland, as he believed he would sell more there because of the rain!

## The trench boot

The First World War saw a great increase in the number of wellington boots being made. These were often known as trench boots, as soldiers wore them in the muddy trenches while in combat. A company called Hunter Boots supplied large quantities of thigh- and knee-high wellingtons.

By the end of the war, the wellington became popular among the general public as wet-weather wear.

The boot had now developed to become more rounded on the toe and to allow more room inside for thick socks. The sole had also become thicker for added protection and comfort while walking. Labourers also used them for daily work on farm land.

**B** The trench boot in the First World War

## The vinyl boot by Mary Quant

In 1964, the famous fashion designer Mary Quant produced a boot design made from vinyl. These boots were nicknamed go-go boots.

Go-go boots were either calf- or knee-high boots, with a low or flat heel, a rounded toe shape and a zipper to fasten them. There was also a high-heeled version in fashion at the same time, known as kinky boots.

## Wellington boots today

Modern wellington boots are made either from rubber or PVC (polyvinyl chloride). They are now used mainly for practical purposes, such as in extreme weather, or for reasons of safety or hygiene. In industry, wellingtons designed with a reinforced steel toe may be used for general safety in a work environment.

**C** Mary Quant's vinyl boots

In recent years, the wellington boot has also developed as a major fashion item, with different patterns on the surface or a differently styled heel, which can be worn to festivals, for example.

There are two key aspects to the development of the wellington boot.

The first is the development of **new materials**. The wellington boot has gone from leather to rubber to vinyl and synthetic materials.

The second is the changing needs or wants of the user. From being designed to meet two very different purposes at the same time, the wellington boot became wet weather footwear, and it is now both a piece of practical workwear and a fashion item.

**D** Wellington boots now come in a range of fashionable patterns

## Summary

- Products can develop in response to the demand of the consumers.
- Products can also develop because of the introduction of new materials and new manufacturing processes.

# Glossary

### A

**Absorbency:** how well the fabric soaks up liquid.

**Adobe Photoshop:** a software package that can be used to help develop and present designs.

**Aesthetics:** how something appeals to the five senses.

**Annotations:** labels added to a drawing that explain its features and help others understand the ideas.

**Appliqué:** stitching one piece of fabric on to another using hand or machine stitches.

### B

**Batch production:** when textiles products are made in specific quantities, or with requirements responding to an order or demand.

**Bespoke:** the product is made directly to the individual customer's needs, so it is unique.

**Blended:** more than one type of fibre twisted together for a mixed effect.

**Bonding:** a method of making fabrics where the fibres are held together by an adhesive material.

**Brand:** the name or other characterisitics by which a product is identified.

### C

**Calendering:** pressing fabric between rollers to make it smoother.

**Care label:** this label has information that you are advised to follow to keep the product in the best condition possible.

**Catwalks:** where models walk on a stage showing the outfits they are wearing to the public.

**Commercial pattern:** pattern sold to the public that has already been tried and tested.

**Components:** things needed to make a product, apart from the fabric.

**Computer-aided design(CAD):** the use of computer software to support the design of a product.

**Computer-aided manufacture(CAM):** using computers to operate machine tools.

**Computer-integrated manufacture:** using CAD to design a product, then CAM to manufacture it.

**Constraint:** things that limit what you can design and make.

**Construction technique:** techniques with a purpose, not just decorative.

**Creativity:** the ability to generate interesting and new ideas and take them from thought into reality.

**Culture:** how beliefs, history and traditions have influenced a group within society.

### D

**Decorative:** making something look better.

**Design brief:** a short statement of what is required in a design.

**Design process:** a sequence of activities carried out to develop a product.

**Durability:** how hard-wearing something is.

**Dyeing:** immersing fibres, yarns or fabrics into a pigment dye to change the colour.

### E

**Edge finishes:** techniques that neaten the outer edges of a product so that they do not fray or go out of shape.

**Embellishment:** different techniques that are applied to the surface of a fabric to decorate it and give it a 3-D textured effect.

**Ergonomics:** the science of designing a product to fit the user: an oven glove that perfectly fits a hand, for example.

### F

**Famous designer:** a designer whose products are well known by the public.

**Fashion drawing:** a sketch of a figure featuring a fashion garment.

**Fastenings:** used to close an opening, or to hold something together that needs to be closed temporarily.

**Features:** details on the design.

**Felting:** a method of making fabrics where moisture, heat and pressure are used to press fibres together.

**Fibres:** long, thin strands of material, which are twisted (spun) together to make yarn.

**Filament fibres:** long fibres, mostly from synthetic sources.

**Fixative:** a chemical (usually salt) added to make sure that a dye is fixed.

**Flow chart:** a sequence of activities presented as a diagram.

**Function:** the task that a product is designed to do.

**Functional:** something with a purpose or job to do.

**Functional testing:** testing in real use to check that the product does what it is meant to do.

## H

**Haute couture:** a French term referring to high fashion, high quality, bespoke clothing.

## I

**Insulation:** the warmth of the fabric.

**Interfacing:** often used under appliqué designs to strengthen them and stop shapes from stretching.

**Iron:** a tool that is used to get creases out of fabrics.

**Ironing:** the process of getting creases out of fabrics using an iron.

## K

**Knitting:** a method of making fabric where a group of loops pulled through each other using needles.

## L

**Loom:** a machine for weaving yarn onto fabric.

## M

**Made-to-measure:** one off garments made for individual people.

**Man-made fibres:** fibres made from wood pulp, oil or coal.

**Market:** the group of potential customers who may buy a product.

**Mass market:** large quantities of clothing made in standard sizes.

**Mass-produced:** items are normally created in high volume numbers with specialised machinery that is rarely stopped.

**Mercerising:** putting fabrics into chemical baths to make them stronger.

**Modelling:** making up a rough version of a product, or parts of a product, and testing them to see if they work.

**Modern** or **interactive fabrics:** fabrics that need a power source to activate their electronic features.

**Moral choices:** decisions about what is good or bad

**Mordant:** the industrial term for a fixative.

## N

**Natural fibres:** fibres made from parts of plants or animals.

**Need:** what the product you are designing must do.

**New materials:** newly discovered or invented materials.

**Non-renewable:** something that is not replaced and will eventually run out.

## O

**Objective:** based on facts rather than opinions.

**One-off:** the product is usually made by one or more skilled people, who tailor the product directly to the customer's needs.

## P

**Patchwork:** pieces of fabric are sewn together to make a new piece of fabric.

**Patent:** a legal protection for a design idea.

**Pattern** or **template:** normally a paper or cardboard shape, from which the parts of a product are traced on to fabric before they are cut out and sewn together.

**Pigment:** the name of the colouring matter used in the dyeing process.

**Plies:** the number of fibres twisted together to create a yarn.

**Pollution:** contamination of the environment.

**Pressing:** applying heat and pressure to create creases or pleats.

**Primary research:** finding out the information you need by yourself.

# Glossary

**Product analysis:** investigating the design of existing products.

**Production line:** in industry, products are usually made by passing each stage of making down a line, using both manual and mechanised methods.

**Production plan:** the instructions on how to manufacture a product.

**Prototype** or **mock up:** the first rough version of a product, which is made up to test the product.

## Q

**Quality control:** these are check points to test, or double check, that a product is being made accurately

**Quality label:** this label is given to a product that has met certain standards that test for quality of the product or how it was made.

**Quilting:** several layers of fabric are sewn together to produce a 3-D padded effect.

## R

**Ready-to-wear:** collections of garments made by a designer or a brand.

**Recycling:** breaking or melting down the material so that it can be used in a new product.

**Reduce:** reducing the amount of raw materials needed.

**Refuse:** not accepting things that are not the best option for the environment.

**Relief:** some areas of a design are raised higher than others.

**Rendering:** applying colour or texture to a sketch or drawing.

**Repair:** mending a product so that it lasts longer.

**Repeat pattern:** a pattern reproduced uniformly across a surface.

**Research:** gathering the information you need to be able to design the product.

**Resist dyeing:** a method that means the dye is prevented from getting to certain parts of the fabric in some way.

**Rethink:** reconsidering the design of the product.

**Reuse:** using the product again.

**Reverse appliqué:** layers of fabric are stitched together, and the top layer is cut away to reveal the layers underneath.

## S

**S twist:** the clockwise twist of fibres.

**Safety label:** this label is given to a product that has passed safety testing standards.

**Scale:** where the size of the design is in proportion to the size of the finished item.

**Seam:** joining two pieces of fabric.

**Seam allowance:** distance from the edge of the fabric when sewing a seam.

**Secondary research:** finding out the information you need by using material that someone else has put together.

**Shading:** creating different tones on a sketch or drawing.

**Shaping techniques:** darts, pleats and gathers, which change a flat 2-D shape to a 3-D shape.

**Sketching:** producing a visual image of an idea by hand.

**Smart fabrics:** textiles products that respond to their environment without human interaction.

**Specification:** a list of needs that the product must meet.

**Spinning:** the process of twisting fibres into yarns.

**Squeegee:** a thin piece of wood with rubber attached to the edge, which is used to evenly push dye through a silk or nylon screen designed for printing.

**Standard:** a document, published by an accredited standards agency, which lists the properties expected of a product and the tests that should be carried out to test those properties.

**Staple fibres:** short fibres, mostly from natural sources.

**Stencil:** a thin sheet of material with a shape cut out of it, through which paint or ink is applied to mark the shape on to another surface.

**Sustainable materials:** material that have less of an impact on the environment.

## T

**Tailor's dummy:** a piece of equipment that is used to draft patterns and garments on, instead of using an actual person.

**Textiles equipment:** different tools used to help plan, mark out, join and decorate fabrics when making textiles products or pieces of artwork.

**Think outside the box:** try to make unusual choices and do not play it safe with your ideas.

**Tjanting tool:** a specialist batik tool designed to carry and apply hot wax to fabric.

**Toile** or **mock up:** a sample product used to test out a design, made from cheap, thin material such as muslin or calico.

## W

**Wadding:** padding used in the centre of quilting to give a 3-D padded effect.

**Want:** features that you would like the product to have.

**Weaving:** a method of making fabric where two yarns, warp and weft, pass over and under one another in opposite directions.

**Worsted:** where yarn is spun tightly, like a rope.

## Y

**Yarns:** fibres spun on to a roll ready to be made into fabric.

## Z

**Z twist:** the anticlockwise twist of fibres.

# Index

## A

absorbency   46
ACCESS FM   8–9, 10–11
acetate   39
Actifwear   57
adapt   22
Adobe Photoshop   23
aesthetic needs   8, 9, 10, 11
Alessi products   23
annotations   24
appliqué   55, 68–9

## B

baby toys   16
backpack   3
batch production   74–5
batik   65
beads   72
bespoke   75, 78
binding   50, 51, 62, 63
biomimetics   52
bleach, use of   49
blended   40, 41
block printing   66
Bondaweb   51, 55
bonding   43
boning   51
boots   47, 80–1
brand   76
British Standards Institute (BSI)   20, 48–9
Burberry   77
buttons and buttonholes   63
by-products   13, 38

## C

CAD CAM   32, 56, 74
calendering   44
care label   48, 49
catwalks   76
CE symbol   20, 48
child's toys   4, 5, 11
choke tester   35
clothing   18, 19
cocoa, making   31
colour   19
colouring fabric   51, 64–7

combine   22
commercial pattern   28
components   50, 51
computer-aided
   design (CAD)   26–7, 29, 33, 57
   manufacture (CAM)   29, 32, 33, 57
computer-integrated manufacture (CIM)   32, 33
computer numerical control (CNC)   32
concept drawings   24
constraints   4, 5, 10, 11
construction techniques   58, 60, 62
Consumer Protection Act   20
Consumer Safety Act   20
cost   19
cost needs   8, 9, 10, 11
cotton   14, 36, 38, 42, 46
creativity   22, 23
culture   18, 19
customers   8, 9, 10

## D

darts   60
decorative   50, 51
denim   42, 45
design blocks   66
design brief   4–5
design process   2
designers   76, 77, 78–9, 81
   role of   76
developing ideas   22
Diana, Princess of Wales   77, 78
drawstring bag   69
dry cleaning   49
durability   36
dyeing   51, 64–5
   thermochromatic   52

## E

edge finishes   62
educational toys   9, 11, 35
elastic   51
elderly people   18
eliminate   22
embellishment   50, 72–3
embroidered motifs   51, 57
embroidery   32, 72, 73

# Index

energy  12
environmental concerns  12–13
environmental needs  8, 9, 10, 11
equipment, textiles  54, 55
ergonomics  23
e-textiles  51
European Safety Standards  20, 48

## F

fabric book  9, 11, 35
fabric
  colouring  51, 64–7
  **interactive**  52, 53
  **modern**  52, 53
  non-woven  43
  **printing**  33, 66–7
  properties  46
  regenerated  39
  **smart**  52, 53
  waterproof  21
facings  62
Fairtrade logo  19
**famous designers**  76, 77, 78–9, 81
**fashion drawings**  23, 24, 25
**fastenings**  50, 62, 63
**features**  27
**felting**  43
**fibres**  36–9
  **man-made**  36, 38–9
  **natural**  36, 38, 39
  properties of  36
  twisting  40–1
**filament fibres**  36
finishes  37, 44–5
  of edges  62
**fixatives**  64
flameproofing  44, 45
flatbed printing  67
fleece (non-wool)  16
**flow charts**  30, 36
football kit  46
footwear  47, 80–1
french seams  58–9
**function** (product)  8, 9, 10, 11
**functional**  50, 51
**functional testing**  34, 35

## G

gabardine  77
gathers  60
global warming  13

glossary  82–5
Goodyear, Charles  80
Gucci  79

## H

Hargreaves, James  41
Harlequin  67
**haute couture**  75, 77, 78
health and safety  65
hems  62

## I

ideas, developing  22
ideas, presenting  23, 24
Industrial Revolution  41
**insulation**  16, 46
**interactive fabrics**  52, 53
**interfacing**  50, 51, 68
**irons and ironing**  49, 55

## K

kitemark  20, 48, 49
**knitting**  42, 43

## L

labelling  48–9
laws  20
LED lights  51
linen  38, 46
linings  62
Lion Mark  48
logos  19
looms  41, 42
lyocell  13

## M

Mackintosh, Charles  21
**made-to-measure**  78
**man-made fibres**  36, 38–9
**market**  4, 5
Marks & Spencer  19
**mass market**  78
**mass-production**  74, 75
materials  12
  and manufacturing needs  8, 9, 10, 11
  **new**  80, 81
  **sustainable**  4, 13, 14, 15, 18
**mercerising**  44, 45
mirror work  73
**mock up**  15, 28, 29
**modelling**  28, 29

# Index

modern fabrics  52, 53
modify  22
mood board  76
moral choices  18
mordants  64
motifs, embroidered  51, 57

## N

natural fibres  36, 38, 39
needs  2–3, 10, 11
  testing against specification  11, 35
new materials  80, 81
non-renewable  12, 13
nylon  38, 39, 46

## O

objective  34, 35
one-off products  4, 75
overlocking  58–9

## P

packaging  12
patchwork  70, 71
patents  21, 80
pattern markings  29
pattern, repeat  66, 67
patterns (templates)  28–9
PET (polyethylene terephthalate)  16
pigments  64
piped seams  59
plastic bottles  16
plastics  16, 17
pleats  44, 60, 61
plies  40, 41
pockets  61
pollution  13
polyester  39, 42, 46
poppers  63
pressing  55
Primark  79
primary research  6, 7
print blocks  66
printing fabrics  66–7
product analysis  8–9
product development  80–1
product improvement  34
production line  75
production methods  74–5
production plan  30–1
protecting work  21
prototypes  28, 29

purse, making  30, 31
putting to other use  22
PVC (polyvinyl chloride)  81

## Q

quality control (QC)  74, 75
quality labels  48
Quant, Mary  81
questionnaires  6, 7
quilting  70–1

## R

raincoats  21
rayon  39
ready-to-wear  78, 79
recycle  3, 13, 14, 16, 17
reduce  14, 15, 16
refuse  14, 15
relief  66, 67
rendering  24, 25
repair  14, 16, 17
repeat pattern  66, 67
research  6–7
resist dyeing  64
rethink  14, 15
reuse  14, 16, 17
reverse appliqué  68, 69
reverse or rearrange  22
Rhodes, Zandra  77
roller printing  67
Rs, six  14–17
run and fell seams  59

## S

S twist  40, 41
safety  20, 31
safety labels  48
safety needs  8, 9, 10, 11
Sale of Goods Act  20
scale  24
SCAMPER  22
screen printing  33, 66–7
seam allowance  58
seams  58–9
secondary research  6, 7
sequins  72, 73
sewing machines  56–7
shading  24, 25
shaping techniques  60
Shisha work  73
shoe caddy  34

# Index

shoulder pads   51
silk   36, 38, 39, 46
six Rs   14–17
size needs   8, 9, 10, 11
sketching   24
smart fabrics   52, 53
smocking   60
social influences   18–19
socks   46, 47
specification   10–11
   testing against   11, 35
Speedo Fastskin   53
spider diagrams   5
spinning   40, 41
spinning jenny   41
squeegees   67
standard codes   59
standards   20, 21
staple fibres   36
stencils   66, 67
stonewashing   45
strength testing   6
substitute   22
sustainable materials   4, 13, 14, 15, 18
swimsuits   53
symbols   17, 20, 48, 49

## T

tailor's dummy   28, 29
Teflon   37
templates (patterns)   28–9
testing strength   6
Texplan Manufacturing Ltd   33
textiles equipment   54, 55
think outside the box   22, 23
threads   50
tie dyeing   64, 65
tjanting tool   64, 65
toggles   63
toile   15
toys
   baby   16

child's   4, 5, 11
   fabric book   9, 11, 35
   safety   48
Trade Description Act   20
trainers   14
transfer printing   67
trimmings   51
T-shirts   24
tucks   60
tumble-drying   49
twisting fibres   40–1

## U

users   4, 11

## V

Velcro   18, 50

## W

wadding   51, 68, 70
Walker, Catherine   78
wallhanging   50
wants   2
warp   41, 42
washing instructions   49
waste   12
waterproof fabric   21
weaving   41, 42, 43
websites   7, 19, 23, 49, 57
weft   41, 42
wellington boots   80–1
Westwood, Vivienne   77
wool   14, 36, 38, 43, 46
woollen spinning   41
worsted   40, 41

## Y

yarns   36, 37, 40, 41

## Z

Z twist   40, 41
zips   63